BURY ST EDMUNDS AT WORK

PEOPLE AND INDUSTRIES THROUGH THE YEARS

MARTYN TAYLOR

AMBERLEY

ACKNOWLEDGEMENTS

I would like to thank the following for their help; anyone I have missed, I apologise: David Addy, Lorna Allen, Apex Marketing/Gerry Gilbert, Roy Atkins, John Boughton, British Library, Rod Brown, Bury Free Press, Bury Past & Present Society, Phyllis Chapman, Jeremy Clayton, Jackie Cook, Mark Cordell, John Crawford, EADT, Glasswells, Christine Harper, Chrissy Harrod, Brian Hoddy, Jackson-Stops & Staff, Jewsons, Brendan Kennedy, Justin Long, M&S Archives, Pawseys, Daphne Pike, Jon Presley, Quality Castings, David Ruddock, Michael Smith, Suffolk Records Office, St Edmundsbury Diocese, Treatt plc, Eric Tricker, Michael Underwood, John Webber, Simon Whitnall, and, as ever, Sandie my wife, without her help nothing would be achieved.

First published 2017

Amberley Publishing
The Hill, Stroud
Gloucestershire, GL5 4EP

www.amberley-books.com

Copyright © Martyn Taylor, 2017

The right of Martyn Taylor to be identified as the Author of this work has been asserted in accordance with the Copyrights, Designs and Patents Act 1988.

ISBN 978 1 4456 6906 9 (print)
ISBN 978 1 4456 6907 6 (ebook)

All rights reserved. No part of this book may be reprinted or reproduced or utilised in any form or by any electronic, mechanical or other means, now known or hereafter invented, including photocopying and recording, or in any information storage or retrieval system, without the permission in writing from the Publishers.

British Library Cataloguing in Publication Data.
A catalogue record for this book is available from the British Library.

Origination by Amberley Publishing.
Printed in the UK.

Introduction	4
In the Beginning	5
A Change on the Way	15
Nineteenth-Century Commerce and Service	27
The Twentieth Century Dawns	39
Post-Second World War Bury	51
A Transformation	63
A Different Bury St Edmunds	75
Town Centre Business	87

INTRODUCTION

The sobriquet of 'Silig Suffolk' is rightly applied as 'holy Suffolk' as the martyred Anglo-Saxon king – St Edmund – was enshrined in West Suffolk's county town, Bury St Edmunds. It was the enormous Benedictine abbey here that owned and controlled the town for over 500 years, for the employment of the townspeople was centred on provisioning this huge religious domiciliary.

As time went by, Bury went on to thrive like the other wool towns, though the guilds and residents did not always see eye to eye with the abbot. Plague brought about a freer labour market, with a living sustainable wage now available for those who chose to work. The eighteenth century saw a downturn in the wool trade and, as such, the unemployment situation had to be addressed – hence the Bury Workhouse, which was followed swiftly by another, the Thingoe Union.

Landed gentry who had developed large estates in the area depended more and more on farming; even the Royal Agricultural Show was held here in 1867. The mid-nineteenth century saw a slow move to industrialisation, then along came Bobys Engineering, brewers Greene King, the Cornish and Lloyd foundry and eventually the sugar beet factory. Trades had always flourished, and the population of the town seemed to fit nicely with the employment opportunities.

This was all to change with the arrival of the London overspill in the 1960s, which brought new labour, jobs, and new hopes. The town's expansion exploded with large housing estates, industrial zones and a new hospital all being built.

The town is still changing today. *Bury St Edmunds at Work* shows how the town is evolving to become not only an important tourist destination, but a very desirable place to live and work.

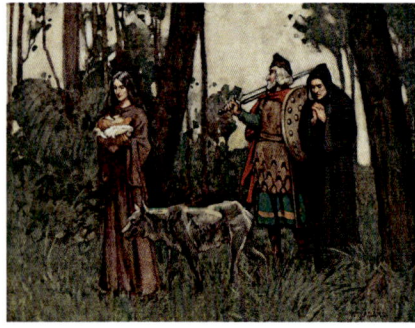

The head of Edmund, who was slain by the Danes.

IN THE BEGINNING

With the coming of the Normans in 1066, the settlement known as Bedericesworth (later to become Bury St Edmunds) was going to increase beyond recognition. They did not need a castle to subdue the inhabitants here, as the township had already been put under the control of a French abbot named Baldwin a year earlier. It was he who laid out the medieval grid that is still evident today; the Domesday Book records that 342 houses were built on land that was previously under the plough. So, what was the overriding factor that led to this urban explosion? It was probably something to do with England's first patron saint, the martyred King Edmund of East Anglia, being venerated – firstly with a wooden church, then by a stone rotunda given by King Canute. However, as neither of these two places of worship were considered to be worthy enough to house his relics, a building plan was put in motion by Baldwin, commencing in 1085 and lasting until the early thirteenth century. This was to be a huge Benedictine abbey with a Romanesque-style church of gigantic proportions, the largest of any in northern Europe. To carry out this work, artisans and craftsmen of the first degree were required – in some cases whole generations of families settled here.

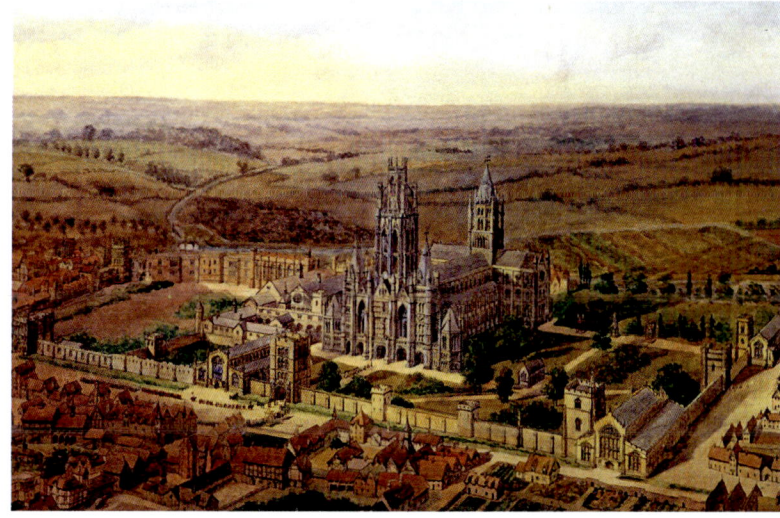

W. Hardy's late nineteenth-century painting of St Edmundsbury Abbey.

BUILDERS OF THE ABBEY: THE MASON

A mason is a man dedicated to his craft, competent in the use of his various tools, design and forward planning. The choice of building stone was that of an oolitic cream-coloured limestone from Barnack on the Northamptonshire border. After being quarried, the stone was probably brought over the then undrained fens via the rivers Ouse and Lark on barges. Divided into sections, the ashlar limestone blocks would progress to a manageable height, where they were left to set before a slurry mixture of lime mortar and flint would be poured in.

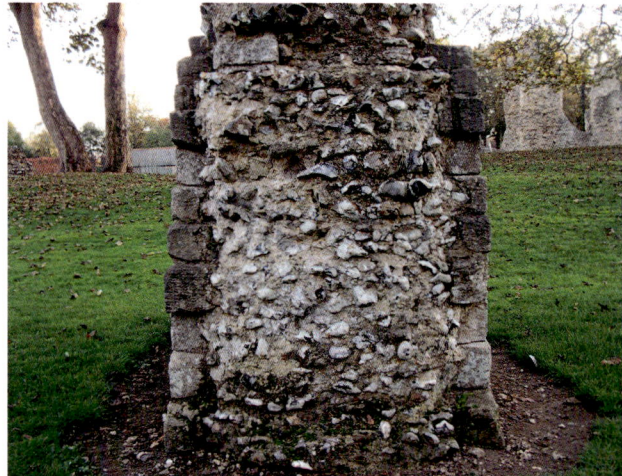

Left: A cross section of an abbey wall.

Below: Jon Presley, modern-day mason, in the Charnel House of 1300.

In the Beginning

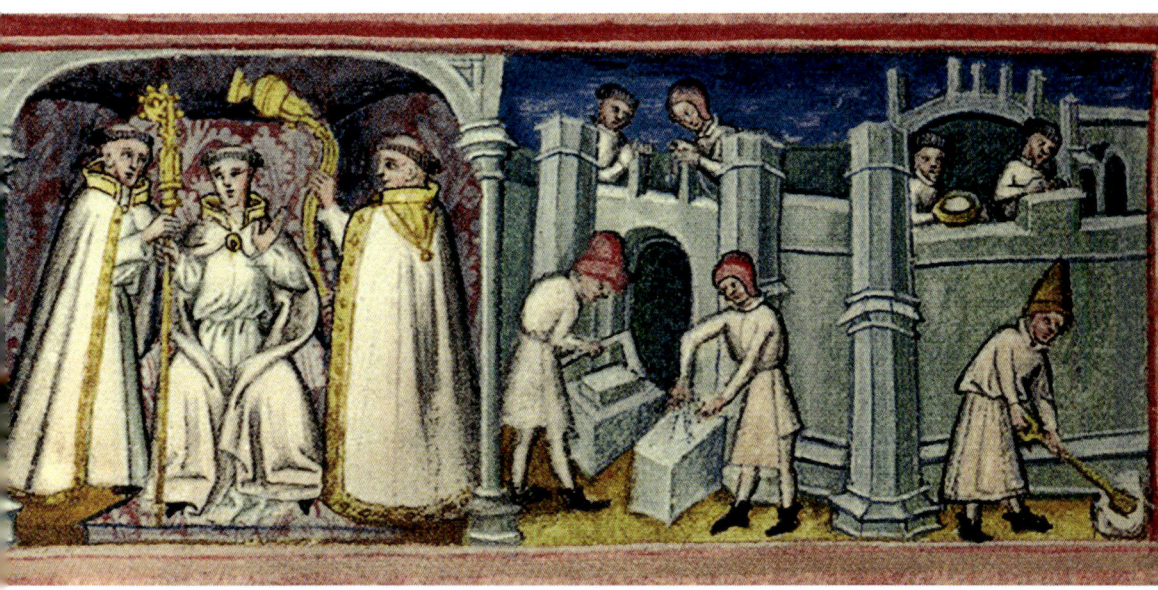

Abbot Baldwin and the building of the abbey, from *The Life of St Edmund, King and Martyr* by John Lydgate. This was given to Henry VI.

Eighteenth-century houses in the West Front under restoration.

OFFICERS OF THE ABBEY: THE OBEDIENTIARIES

For any well-run institution to function, its workforce has to operate like a well-oiled machine. The abbey's office holders had to obey the mitred abbot, who represented the town in Parliament – he only had to answer to the pope as the abbey was free of episcopal control. Second in command was the prior. He dealt with matters that, though important, did not need to concern the abbot – in the Peasants' Revolt of 1381 the unlucky Prior Cambridge was decapitated when the townsfolk vented their anger at the all-controlling abbey. Next in line was the subprior, followed by the cellarer, who was accountable for provisioning this monastery; bakeries, brewhouses and supplies from the town itself were under his control. Undoubtedly, there were those that feted him as his office was somewhat powerful – at one time he could even assert his authority to have the dung in the town collected for the abbey. Another important officer was the sacrist, who was responsible for the buildings and infrastructure of a religious house, including all that was required in its running; he also collected the donations made by pilgrims at Edmund's shrine. There were several other posts too such as the hosteller, who looked after visitors and pilgrims; the almoner, who gave charity to the poor and less fortunate; and the comptroller, whose job it was to provide rush mats, pots and pans to the refectory and even to weigh out the cheese for the sixty–eighty monks that were here at any one time.

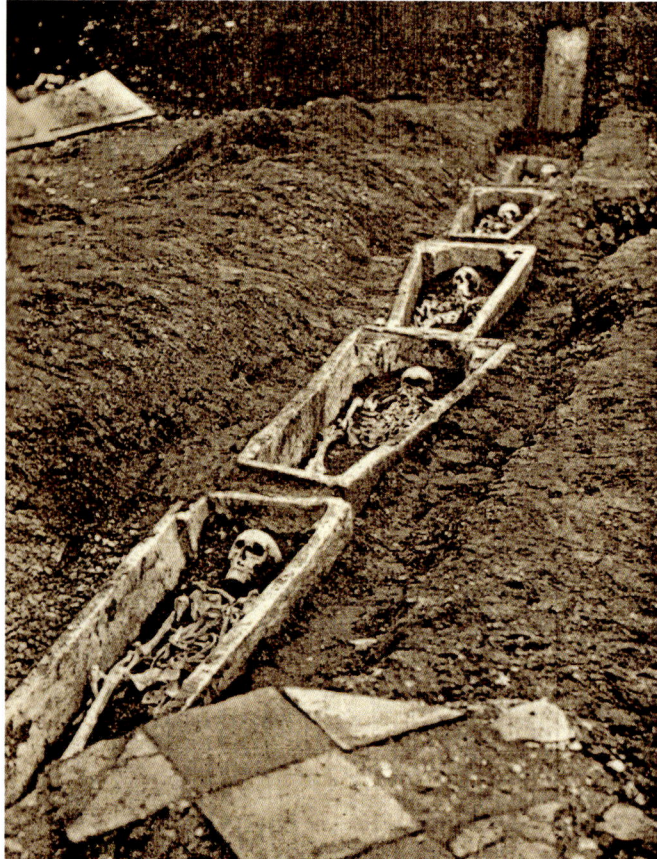

Graves of five abbots exhumed on New Year's Day in 1903.

In the Beginning

MEDIEVAL TRADE

The feudal system, which existed in England in one shape or another until around the end of the fourteenth century, meant that a serf would work for his lord five to six days a week and then on his own holding. A villein was a tenant farmer who would pay his lord in dues and services in return for land – both were subject to pay tithes. Here in Bury no one could grind their grain in any mill other than the one within the abbey, which was of course chargeable! Pre-Conquest, St Marys Square (aka the horse market) was the marketplace. Afterwards, it was held at the Great Market, todays Cornhill.

Bury St Edmunds' commerce was to thrive with the arrival of its first chartered fair during the reign of Henry I around 1125. Other fairs followed and were normally held on religious feast days and jealously guarded by the abbey as it gathered up the tolls they created. King John was persuaded to agree that no other fair or market could be set up in the Liberty of St Edmund (which was to become West Suffolk). A special court, with the rather splendid name of piepowder (meaning dusty feet from travelling), was even set up to settle disputes held in these Bury fairs. St Matthew's Fair was undoubtedly the most popular and was held in September on Le Mustowe. Its most celebrated local visitor was that of the former Queen of France, Mary Brandon, Duchess of Suffolk, sister of Henry VIII. From being an important trading venue selling exotic goods such as damasks, silks, perfumes, spices etc., the fair developed over time to become a marriage mart where prospective partners could meet. This was abolished in 1871 by an Act of Parliament for being 'long past its sell by date'.

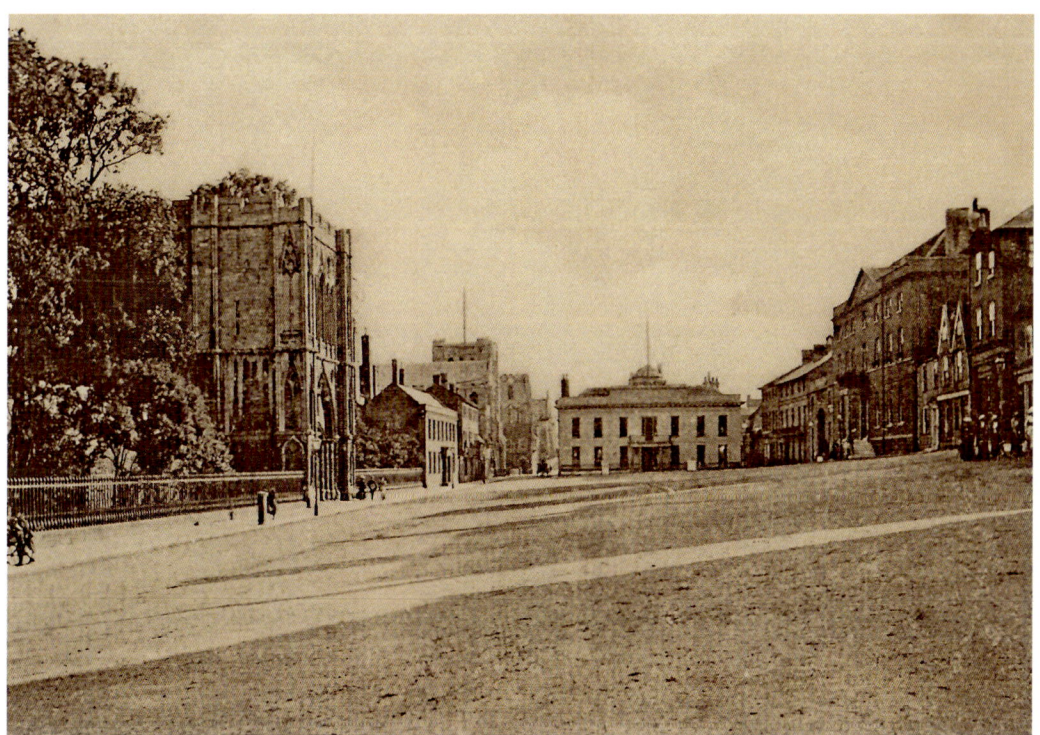

Angel Hill, formerly Le Mustowe.

THE GUILDS

East Anglia was medieval England's industrial heartland, and where the wool trade was prevalent. Bury St Edmunds was no exception and the many workers employed to work within this industry – such as shearmen, combers, fullers, dyers and weavers – gradually organised themselves into guilds. The abbot did not look favourably on the guilds as he thought they would be in direct opposition to his authority.

At the beginning of the thirteenth century, Bury was listed as one of the highest producers of cloth in the country – coverlets subsequently manufactured here were renowned for their quality. Between 1354 and 1530 there were eighty-six listed vocations in the town, with the highest number associated with the wool trade, so it should not be surprising that the guilds reflected this. Some of the earliest guilds were the Alderman's Guild, Guild Merchant, the Dusse Guild and the Candlemas Guild, which was to evolve into the Guildhall Feoffees (still in existence today). Guilds regulated the quality of work produced and those who were eligible to carry it out. The cloth was subject to alnage, essentially a quality and size check made by the king's official, an alnager. As was common throughout the land, apprentices were taught the nuances of their craft by artisans. In 1647, Puritan extremism in the town led to apprentice riots when Christmas was cancelled.

Burgesses in Bury, members of the privileged class, either landowners or householders, represented mainly their own interests by being members of a guild. Not all of the wealthy in the town were associated with the wool trade; for example, John Nottingham, a grocer, left money in his will in 1437 to have a porch built on the north side of St Marys – it is still there today.

In Latin on the porch: 'Pray for the souls of John Nottingham and his wife Isabella'.

In the Beginning

THE MERCHANTS

Two of the town's greatest benefactors were John Baret and the founder of the Guildhall feoffees, Jankyn Smyth. Both fifteenth-century merchants, they are remembered today in St Mary's Church by Baret's gift of the wonderful angel roof, his own Pardon tomb, and by Jankyn's endowed service from 1481. They were both prominent in Bury society, Jankyn more so as he was alderman seven times.

Above: The ancient Guildhall, parts of which predate 1200.

Right: John Baret's tomb.

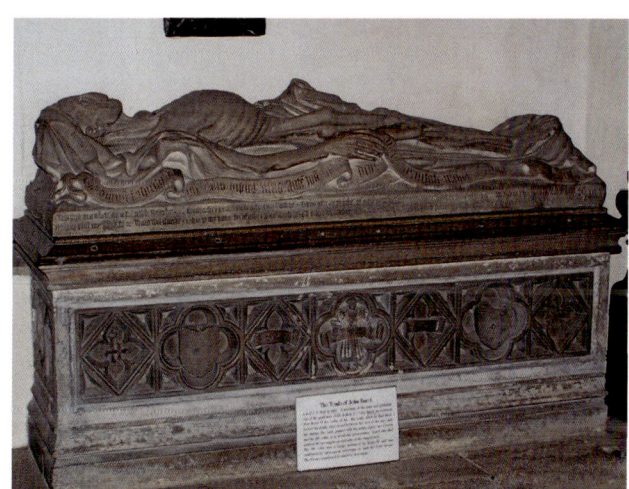

THE WOOL TRADE

The growth of the town had been reliant on the worsted wool trade for many years and, as such, labour intensified. The work was carried out either within the merchant's premises or it was outsourced. Yarn maker James Oakes had inherited a wool and clothier business in 1768 from his uncle Orbell Ray. He had combing sheds and warehouses in St Andrews Street South and often went to Stourbridge Fair to purchase wool for his highly skilled wool-grading sorters, warehousemen and combers, who used heated iron combs to draw out the fibres. It was thought that a good comber could deliver 33 pounds of combed wool for thirty spinners a week – Oakes probably employed 1,500 throughout Suffolk. Many were women who worked within their own homes, which gave rise to a 'cottage industry'.

In 1788, utilising local magnates such as Sir Charles Davers MP and the Duke of Grafton, James had successfully lobbied Parliament to introduce a bill to restrict wool exports. The fact that Bury had two wool halls reflected the amount of business carried out, the broadcloth that was manufactured in Suffolk being extremely popular. The influx of Flemish weavers, imported textiles, and the Napoleonic Wars were eventually to sound the death knell of the town's association with wool. In 1807, James declared that, out of the town's population of 7,500, there were 4,500 paupers, an astonishing claim that reflected the lack of employment opportunities available at the lesser end of society. The last wool merchant in Bury, as listed in a directory, was Clayton Schofield, whose warehouse further down St Andrews Street South has an inscription from 1897 on the gable end to celebrate Queen Victoria's Diamond Jubilee; though it has to be said Eastern Wool Growers were trading from here in the 1960s.

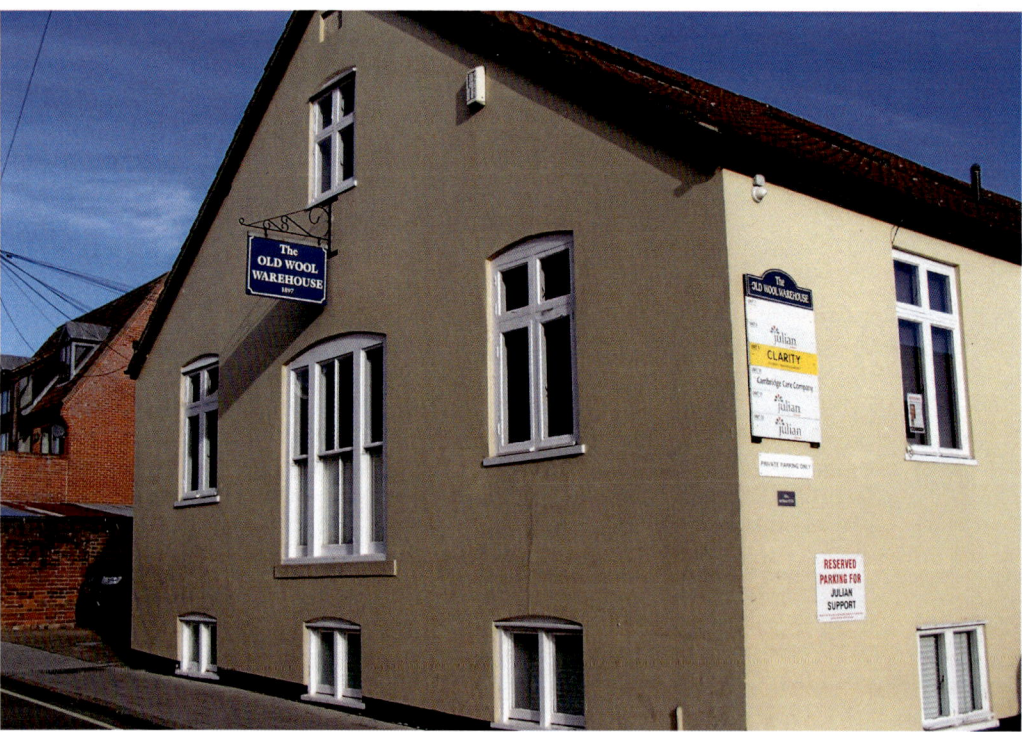

The old wool warehouse.

In the Beginning

The Protestant martyrs' memorial with Robert Miles (wool shearman), John Dale and Robert Lawson (weavers).

The timber-framed Spinners House of John Baret's workers.

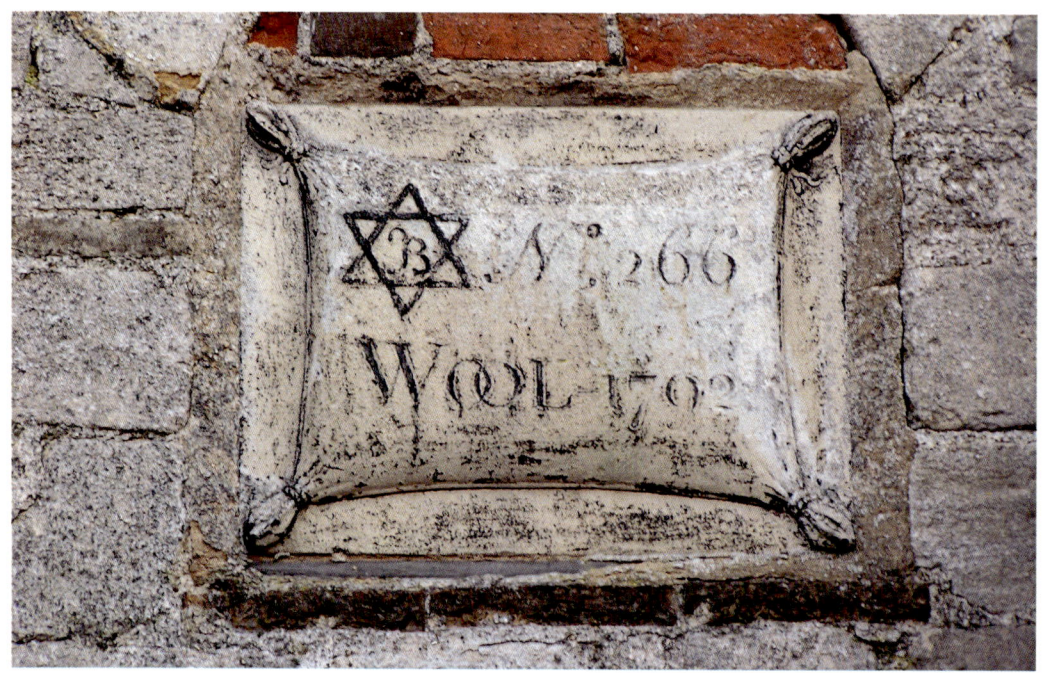

Woolsack in St Andrews Street South – the letter B is for William Buck, once partner to James Oakes, yarn merchant.

A resited plaque showing the boundary ownership of James Oakes.

A CHANGE ON THE WAY

Towards the end of the eighteenth century, with the decline of the wool trade, James Oakes successfully went into banking. His former partner, William Buck, went into business with brewer Benjamin Greene from Oundle and together they purchased the Westgate Brewery in 1804 from the executors of the deceased owner Matthias Wright. Other repercussions of the decline were the Woolhall (where Woolhall Street is now) getting demolished in 1828 – its owner, John Green, had gone bankrupt five years earlier; also, the Corporation Woolhall near Meat Market leased to James Matthew closed.

Agriculture played an important part in local life. As land enclosures started to bite, more people fell into pauperism and so another workhouse – the Thingoe Union in Mill Lane (Road) – opened in 1837. 'Man cannot live by bread alone,' or so the scriptures say, but it was a necessity where the poorer elements of society were concerned. Workers relied on this staple. So much so that there were the so-called bread or blood riots in the early nineteenth century. These threats were exacerbated by mechanisation – new machines that put farm labourers out of work. The so-called Swing Riots (named after the anonymous 'Captain Swing' who stirred up trouble – in effect, an agricultural Luddite) resulted in Bury having thirty people arrested in 1830 for breaking farm machinery.

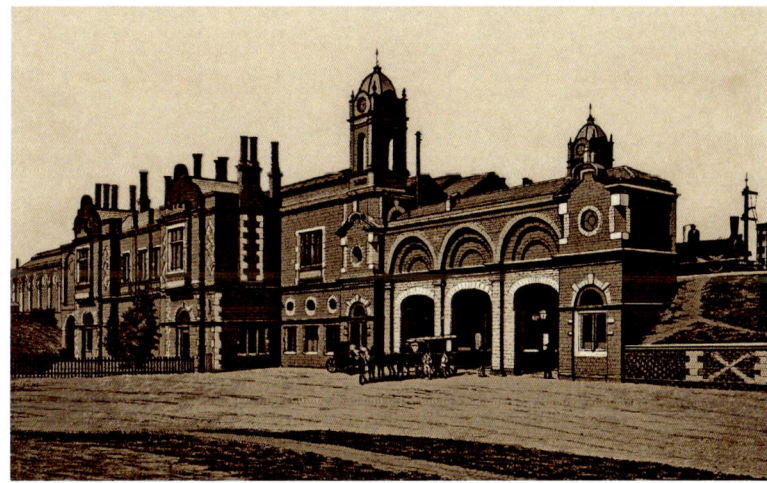

The start of a new life for some.

With the coming of the railway to Bury in 1846 you would have thought that the town's population would have grown considerably with an influx of newcomers, but records show that the opposite occurred. People now found a way to escape the constraints of the town, and a new life beckoned for some. Slowly but surely, factory work became an alternative to working on the land, especially up north.

THE GASMAN COMETH

Early in the nineteenth century it was discovered that by heating coal to a high intensity a combination of hydrogen, methane and carbon monoxide were released. This lead to coal gas or 'town gas', which, when properly controlled, was initially utilised in street lighting. In 1834, the Lighting and Paving Commissioners of Bury decided to make improvements to the town, so two men, T. S. Peckston from Jersey and John Malam from Hull, were contracted to establish a gasworks in the Tayfen area with all necessary equipment, machinery and pipework to public buildings and lamps in the town. Their company only lasted a few months before it was taken over by a consortium of interested local businessmen, who would become known as the Bury St Edmunds Gas Light Co.

Abbeygate Street was the first in the town to be lit up. Although slightly dimmed, the effect was amazing and gradually the rest of the town centre received the benefit of street lighting. A telescopic gasholder was erected in 1857, followed by a second in 1876 and a third in 1952. For obvious reasons, the workers were issued with strict rules and regulations as to their conduct on-site – the Tayfen area was the industrial district of the town and had numerous public houses dotted around. With the discovery of natural gas in the 1960s, the days of the gasworks were numbered since the cost to produce gas through heating became unviable. The gasworks closed in 1964 and the remaining gasholder was used to store the imported gas. This was demolished in 2016 for the National Grid by KDC, specialist decommissioning and demolition contractors in preparation for the town's development plan, known as Vision 31.

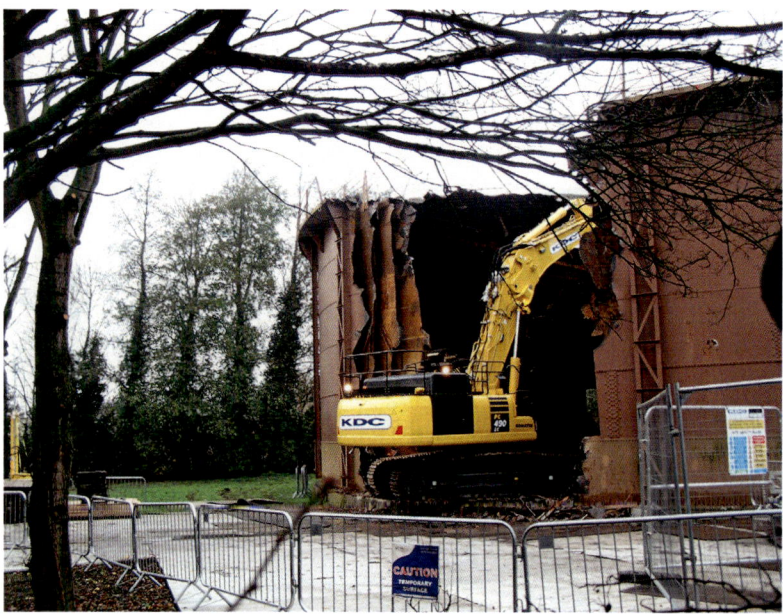

The last gasholder.

LIMEBURNERS

The ancient trade of lime burning was still active in the nineteenth century, although it was nothing like the previous centuries when chalk was mined from tunnels deep under Bury, which was important to create the lime mortar for the building of the abbey. Lime was also used in agriculture as a soil additive to reduce soil acidity and the limeburning Bullen family were very much to the fore in and around the Mill Road area. Limekilns are shown on several maps of the town. William Warren of St Andrews Street South was one of the last exponents of this profession.

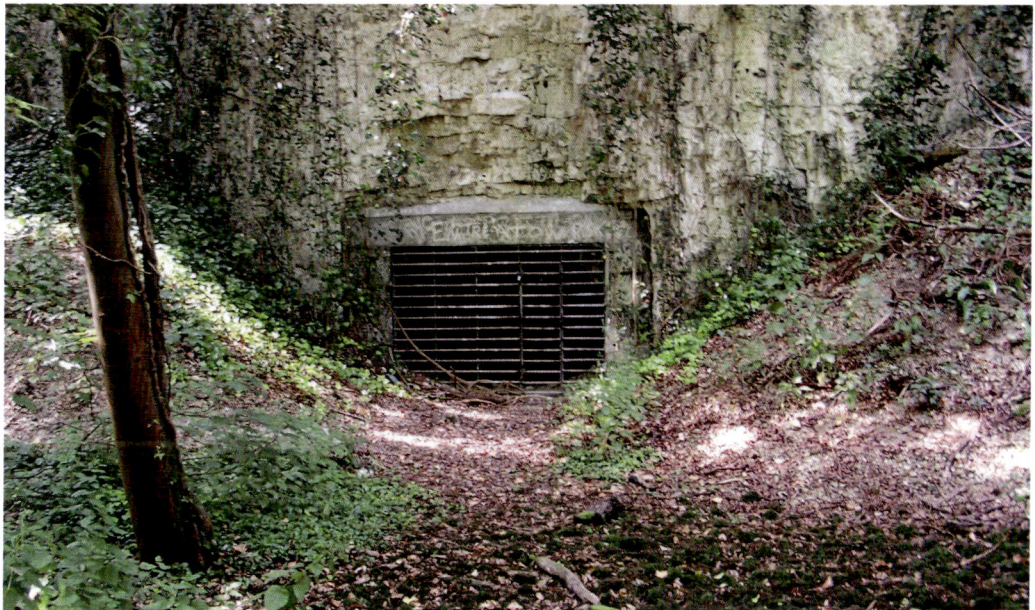

Above: Entrance to a chalk mine at the rear of Clarice House.

Right: A restored limekiln.

STATION HILL

A mill belonging to the Burlingham family stood on Station Hill from 1867 onwards. From its initial beginnings as a grist mill, it progressed to extracting the husk from trefoil seed and then on to removing ribgrass from clover seed. Unfortunately, fire devastated the mill in 1936, though it was soon rebuilt with more up-to-date equipment and employing additional staff. The mill eventually closed when the company moved out to Ingham several years later. Many industrial and commercial buildings from the nineteenth and twentieth centuries have now been demolished, including the former coal business of brothers Robert and George Boby from 1872 and the Brazilia nightclub.

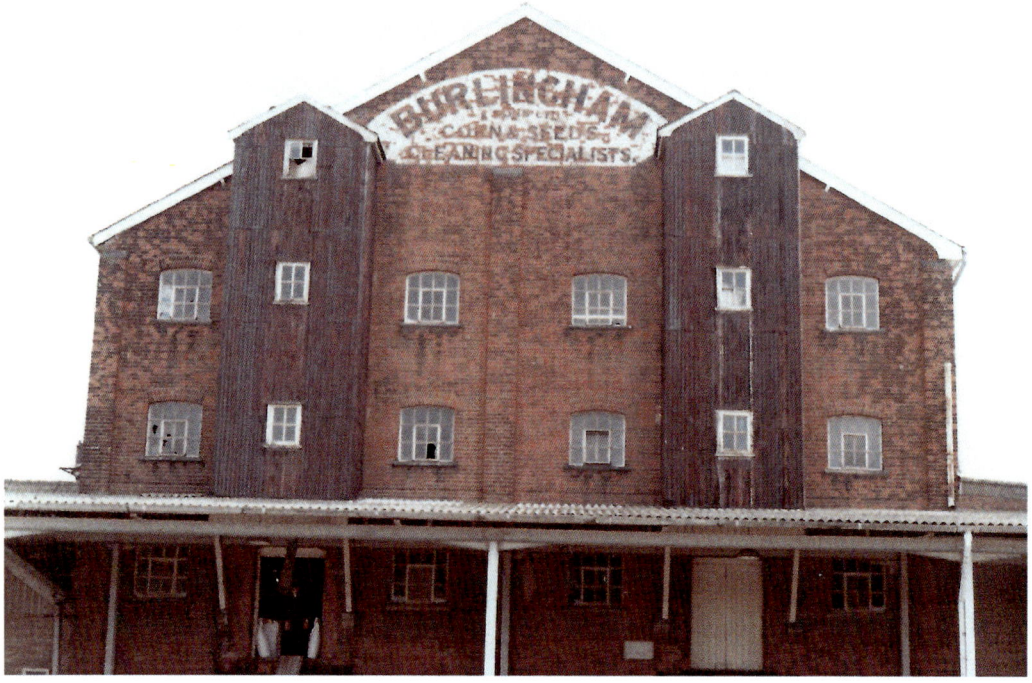

Above: The retained Burlingham's Mill awaiting redevelopment.

Left: Brazilias reduced to rubble.

THE LARK NAVIGATION

The River Lark had carried goods to Bury for centuries. Its improvement was known as the Lark Navigation and was approved by a parliamentary Act in 1699. Work was completed around 1715, though not right into Bury as the Corporation banned it from coming any further than St Saviours Wharf. Owner Revd Sir Thomas Gery Cullum's legal battle over this ended with the coming of the railway in 1846 and his death in 1855. Despite various takeovers and numerous Irish navvies working on the river, any ideas of recreating a major trading route were finally shelved by the beginning of the First World War.

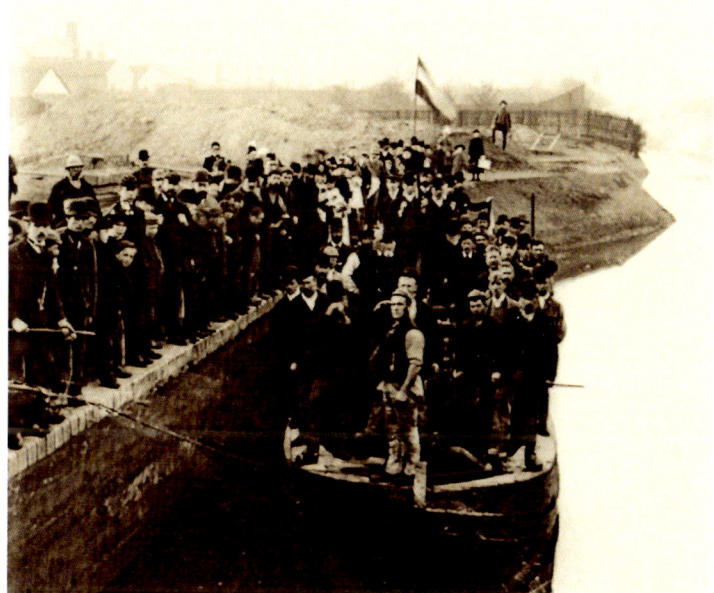

St Saviours Wharf.

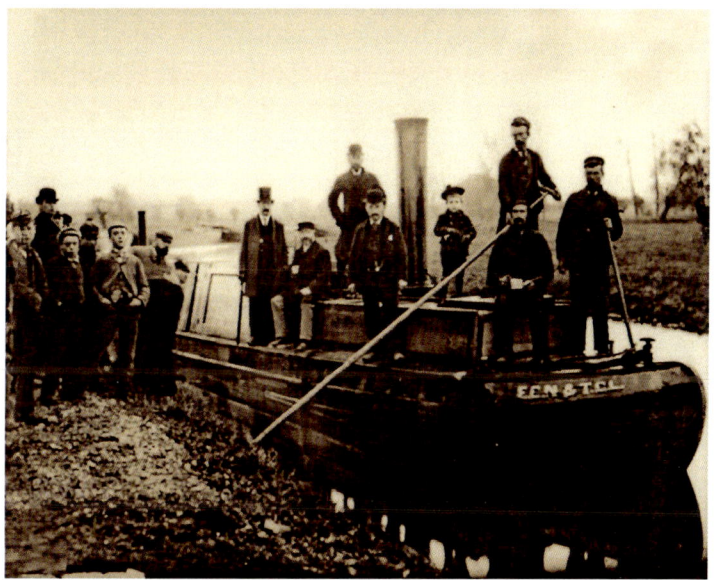

Steam tug on the River Lark.

ROBERT BOBY

Metalworker Robert Boby had, in 1843, started out pretty low-key, but progressed to purchase 7 acres between St Andrews Street South and Cemetery Road to build his St Andrew's Ironworks manufacturing agricultural equipment. In 1856, his company had only managed to turn out 200 corn screens, but by 1887 an astonishing 13,000 had been distributed throughout the world. This may have had something to do with the saying that 'every cloud has a silver lining', because ten years earlier a massive fire devastated the site, resulting in newer machinery being installed and better working practices. By now Bobys were possibly the largest employer in the town, with 200 people on the payroll. After Robert died in 1886, other family members – including his nephew Charles Mumford – ran the company, which had won numerous awards, including some fifty medals for the quality of their workmanship. In 1900, the Northgate Foundry (Boby's second foundry) was built to cope with the amount of extra castings required, with the workers housed in new cottages, The Klondyke.

During the First World War St Andrews Ironworks, involved with the manufacturing of munitions, narrowly escaped bombing by a Zeppelin. The company was eventually taken over by Vickers Ltd of Barrow-in-Furness by 1927. In time, Bobys' employees had successful football and cricket teams, their camaraderie stretching to the various nicknames given to each other such as 'Bootsie' Mick Sergeant or 'Zuby' David Coe. The Northgate Foundry closed in 1966 and in 1971 the Bobys factory closed, although some design staff continued to be employed until 1973. Eventually Bobys became a trading estate called Robert Boby Way; however, the former carpenter's shop can be seen today, reconstructed at the museum of East Anglian Life at Stowmarket.

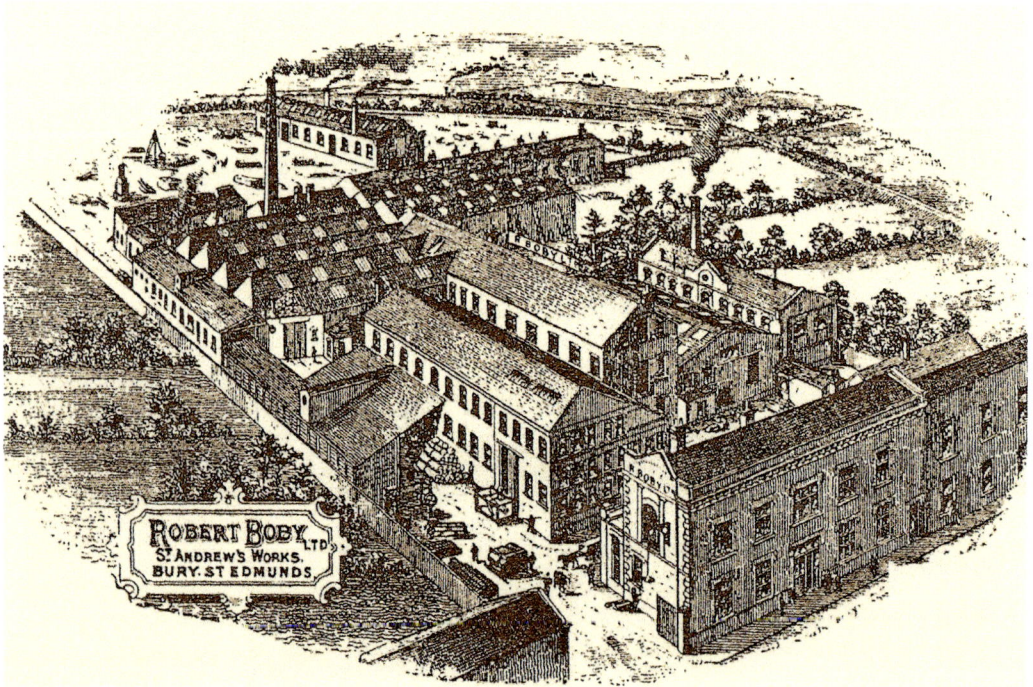

Boby's site plan.

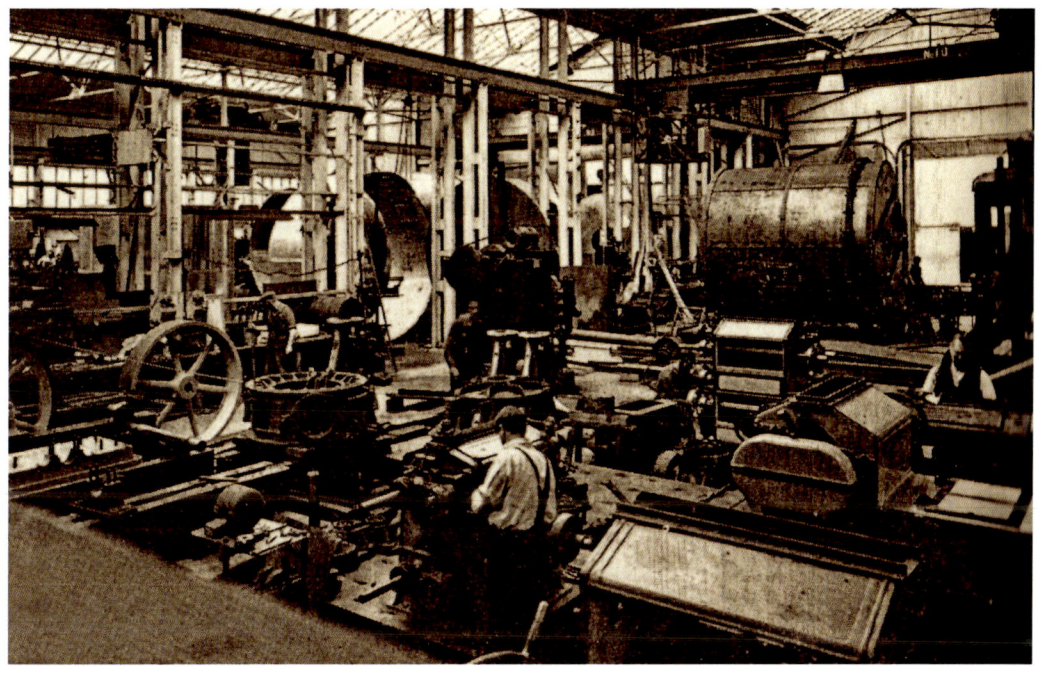

Boby's cricket team of 1965.

Boby's workshop, 1953.

CORNISH & LLOYDS

George Cornish (born in 1824) learnt his trade while working for his father's firm, John Cornish Iron & Brass Foundry. Around 1855 George left to go to work for the expanding firm of Robert Boby, who were primarily engaged in the manufacture of agricultural machinery and implements. Aged forty-one, he had progressed to become Robert's manager but then left to run the family business, Cornish & Sons in Whiting Street, after his father had died. Renamed Cornish's Foundry, he relocated to Risbygate Street on the corner with Chalk Lane (Road). Cornish's Foundry went on to employ fifty people, manufacturing items for agriculture and boilers as well. By 1881 two nephews from Glamorgan had joined the firm, George Lloyd and William Arthur Lloyd. They lived at the registered address of the company at No. 44 Risbygate Street, but it seemed foundry work wasn't to William's liking because by 1890 he was living at No. 14 Albert Street and working as a traveller and insurance agent for The Queen Insurance Co.

As an upstanding member of the community, George Cornish became mayor of Bury from 1891–92. He sadly he died in 1897. The business changed its name again, becoming Cornish & Lloyds, and traded throughout much of the twentieth century. They advertised on a regular basis, especially that they were distributors in West Suffolk for international tractors and machinery and were agents for all other leading manufacturers. After eventually closing their premises in Risbygate Street in 1972, they relocated to the newly built Northern Way industrial estate off Mildenhall Road, which opened on 30 October 1974. A B&Q store is now trading from the Risbygate Street site.

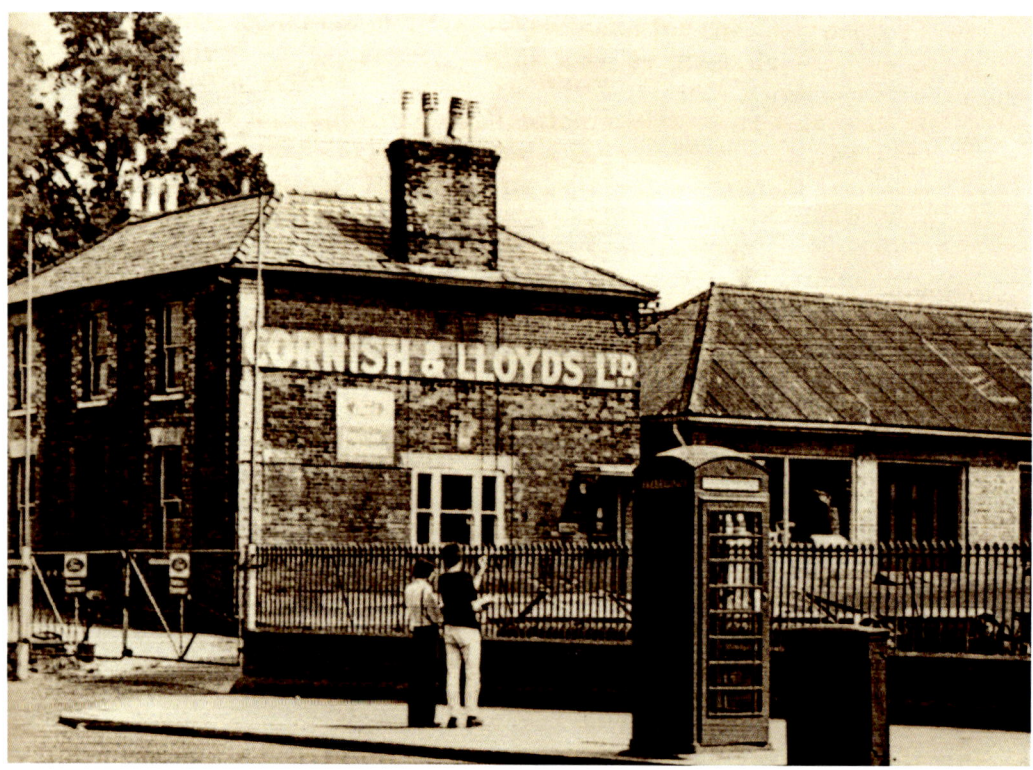

No. 44 Risbygate Street.

WINDMILLS

The Limmer family owned windmills in Field Lane and Mill Road and were still in much use during the nineteenth century. Wind power was gradually superseded by steam engines, such as that which drove the sails of John Cooke's mill in Southgate Street – when it was not blowing! West Mill in Horringer Road was the last working windmill in Bury. It was demolished in 1918 when owned by the Catchpole family.

Right: Remains of a windmill on Kings Road (Field Lane).

Below: West Mill.

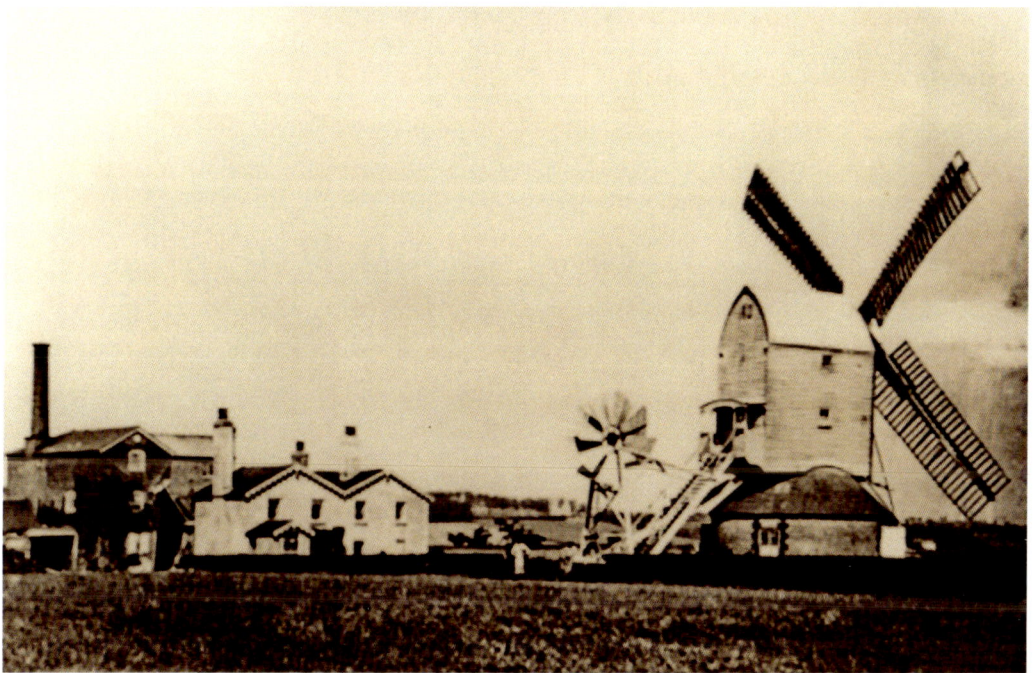

MALTINGS

Some of the biggest employers throughout the nineteenth century were those engaged in the preparation of barley for the brewing of beer – germinating barley had to be continuously raked on the maltings' floor. Amazingly, Bury had twelve separate malsters in 1844. In 1852, farmer Frederick King had married Emily Maulkin, the eldest daughter of Robert Maulkin, one of Bury's major malsters. Fred then set up his own brewery, the St Edmund Brewery. In 1868, Edward Greene had purchased the recently deceased Henry Braddock's Southgate Brewery, along with the maltings and pubs to stop them falling into rival Fred's hands. In 1880, Edward built his own large Foundry Maltings and, seven years later, amalgamated his Westgate Brewery with Fred King to become Greene King. Len Bridgeman of Nowton Road can remember his father (born in 1874) telling him of his time at the Greene King Maltings; for the first part of his working life he worked in maltings at Mistley, Sudbury and Stowmarket, before joining Greene King as foreman of No. 1 Maltings in September 1917. This particular building, situated near today's BMI hospital, was burnt out in 1918 after a grain dryer overheated. Mr Bridgeman Snr retired in 1939 and his son Len, born in 1905, left recollections of working in the barley store in St Marys Square at the tender age of fourteen. The hours varied according to the shifts you worked – even Saturdays from 6 a.m. to 1 p.m. Wages – 41s per week – progressed depending which maltings you worked in. Greene King had several maltings, ranging from No. 3 in Sparhawk Street next to the barley stores, the Foundry fronting Westgate Street and the adjacent Rink Maltings on the corner of College Street, so called because a skating rink was once close by. Today malting uses the modern revolving drum method, which replaced the floor system in the preparation of barley.

The 1880 foundry and Rink Maltings. Since 2004 this has been residential.

The former Dunnells Maltings, Mildenhall Road, now thirty-five flats.

H & D Taylors Maltings in Out Northgate. This ceased trading in 1973.

THE SNUFF FACTORY, WHITING STREET

The tobacco plant came from the Americas. One method of using the addictive nicotine is to ingest powdered tobacco via the nasal passage – known as snuff. The industry expanded across the country as the craving for snuff grew more and more popular. Leaves or even stalks would be cured or fermented with additives such as scent or essences to give it a distinctive flavour. Workers, mostly women, stripped tobacco leaves and then milled them into the fine powder known as snuff (which was used by the better class of persons at first).

It is thought that the Snuff Factory, set back off the road in Whiting Street, dates from the early eighteenth century. It was obtained in 1845 by Joe Hurst, who turned it into a tobacco and snuff factory, and then Bury grocer Thomas Ridley purchased the enterprise in 1892. He was a prominent member of Bury society, becoming mayor in 1878 and 1882, and a leading light in the Baptist church in Bury. Thomas Ridley & Son continued the tobacco and snuff business up to 1911. From 1919 the building was owned by baker and confectioner Charles Goymour until sometime after the end of the Second World War when a piano workshop was here. Over a nearly three-year period from 1998–2001 the derelict building was transformed into a home by John Wilson and his wife Gwendoline with project manager Jeremy Shepherd. During the renovation, builders G. Bream & Son uncovered items of memorabilia, including cigarette and snuff labels and an envelope addressed to Thomas Ridley from the then American tobacco giant W. D. & H. O. Wills – conformation of the building's past life. The three-storey property, now Grade II listed, is constructed from red brick with flint panels and was put on the market in 2011 with Jackson-Stops & Staff.

The renovated Snuff Factory.

NINETEENTH-CENTURY COMMERCE AND SERVICE

Bury was well served by a variety of shops and businesses. Each enclave of the town had all that was required for residents; there was no need to travel too far to get your bread, meat and groceries as it was there on your doorstep. But all this was to change after two world wars. This is not to say that the obligatory visit to the twice-weekly markets were neglected, meeting old friends and catching up on recent gossip was still an important way of socialising. So often it is said that 'a bad name always travels faster than a good one'. This truism still holds fast today and in yesteryear it was just as important – good service was the anchor of any business.

In the mid-1800s there were over forty bakers and flour dealers in Bury, along with nearly thirty butchers and forty-five boot and shoemakers. These are amazing numbers considering Bury's population was under 14,000 at this time. The first real census returns (in 1841) and subsequent ones not only listed the occupants of a particular property but also their employment. The returns also show the ages from which children were put to work to help with the family budget – large families were the norm with the example set by Victoria and Albert. With the 1870 Education Act, education became compulsory for children aged between five and twelve. Despite this, it was accepted common practice that many young girls would go into domestic service. Nationally, over 1 million people were employed as such up to the First World War.

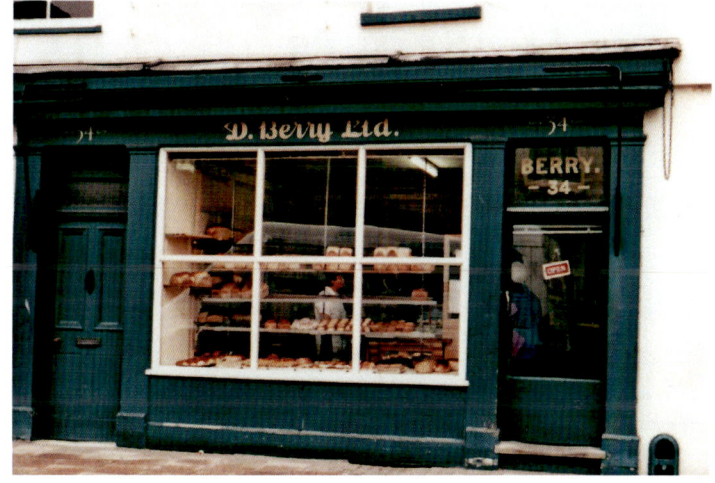

Berry the baker of Churchgate Street. This closed in 1999 after ninety-four years, though an earlier bakery was here.

ABBEYGATE STREET SHOPPING

Once given the sobriquet of the Bond Street of Bury, nineteenth-century Abbeygate Street had an eclectic mix of shops. Thomas Ridley founded a wonderful grocery and provisions shop here that was noted for cured meats, coffee, cheeses and exceptional service until it sadly closed in 1996. Olivers, a similar business at No. 11, had the first telephone number in the town, Bury St Edmunds One. A business still going strong today is that of Thurlow Champness, a jewellers established in 1901 when he acquired the watchmaking business of John Thomas Richardson. Nowadays, the street is part of the 'café culture', consisting of numerous restaurants and coffee shops including some with pavement tables.

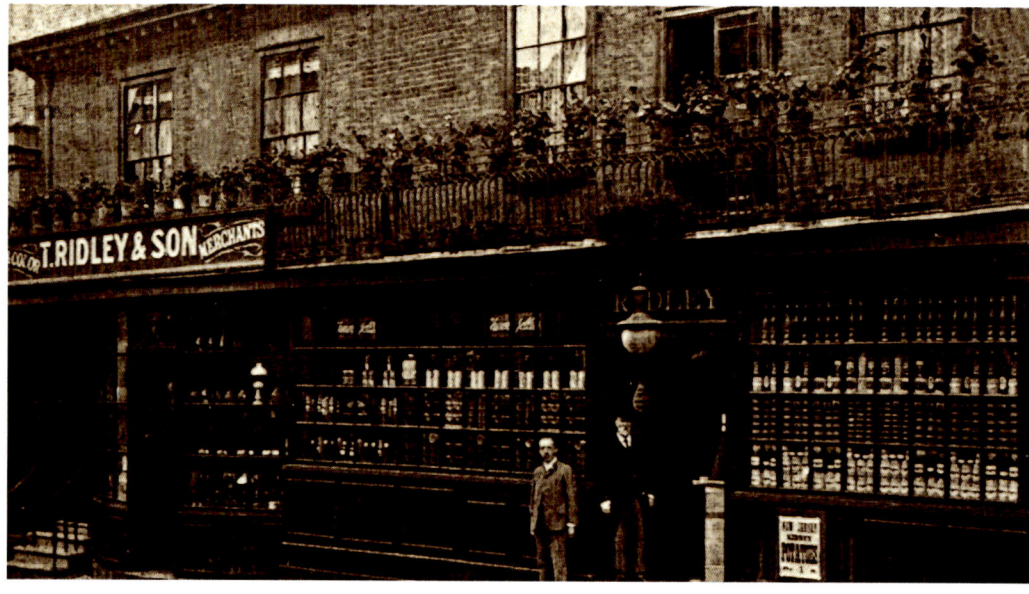

Above: Thomas Ridley's shop at Nos 35–36.

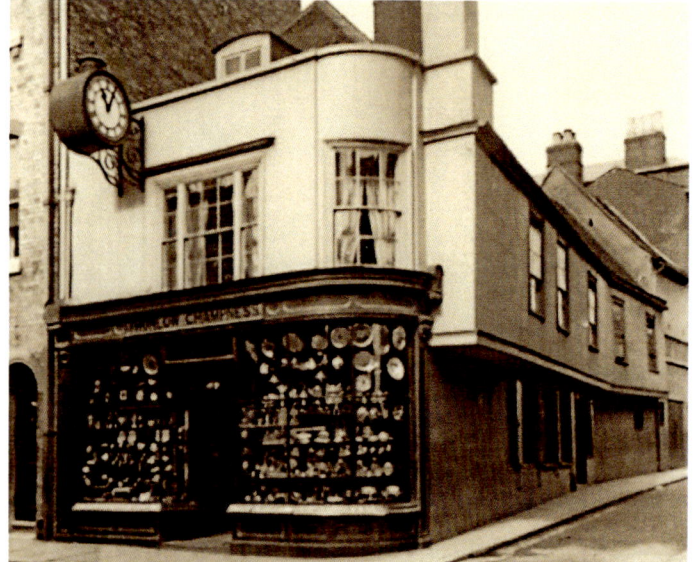

Left: Thurlow Champness at No. 14.

Nineteenth-Century Commerce and Service

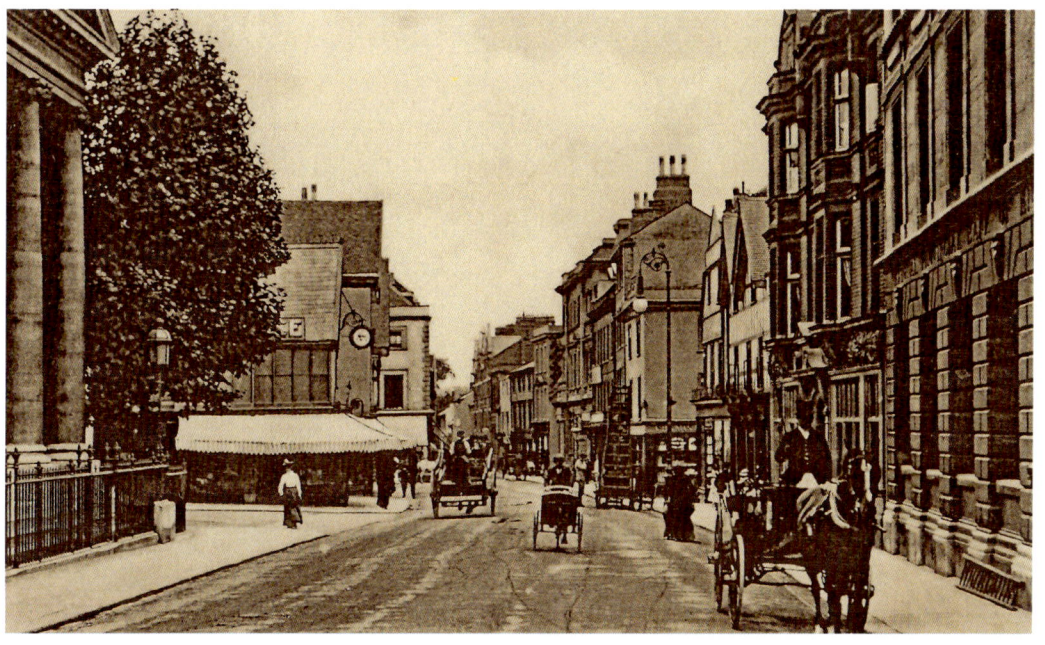

Looking down a busy Abbeygate Street c. 1900.

Note the changes: traffic is one way and there are no more horses.

CHEMISTS

Thomas Hinnel of College Street and John Nunn of Abbeygate Street opened their chemist shop in 1831; you can still see a vestige of their business, a pestle and mortar on the façade of No. 12. Another, older, chemist shop from 1789 was on the corner of Whiting Street and Abbeygate Street; father and son William Ellis and Charles Walton Crasweller ran this from 1854–96. A splendid ancient carved corner post is a striking feature here that Alec Clifton-Taylor, an architectural historian and TV presenter, enthused about, as well as the many timbers and its Jacobean staircase within. However, Warrens, local builders of some repute, supposedly installed the staircase during a makeover much later when the shop was Smalleys – a chemist from 1956–71.

Across on the Cornhill, the current premises of WHSmith were once a branch of Boots the Chemists. Architect Michael Vine Treleaven's designs were used nationwide for Jesse Boot. It was common for his shops to incorporate local figures who contributed to the history of that particular town. This pseudo-Jacobean building has four niches containing statues of Edward VI, Edward I, St Edmund and a Roman, possibly Agricola, governor of Britain. At the very top in relief is King Canute rebuking his flatterers – he was a great benefactor of our town. Previous to Boots, this site was that of another chemist, ardent Methodist and twice mayor, James Floyd. His business was in existence for nearly thirty-five years, selling, among other remedies, tinctures, globules and titrations from natural sources until it closed in 1908. James passed away in 1910, the year Boots was built.

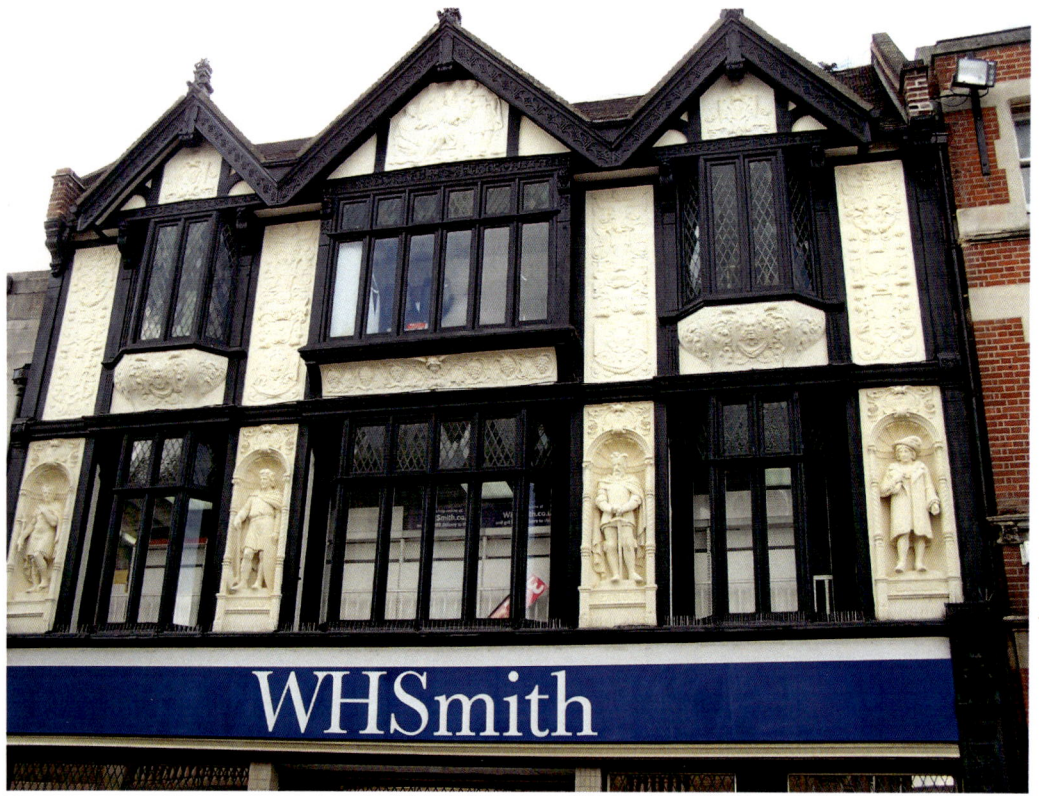

The former Boots building.

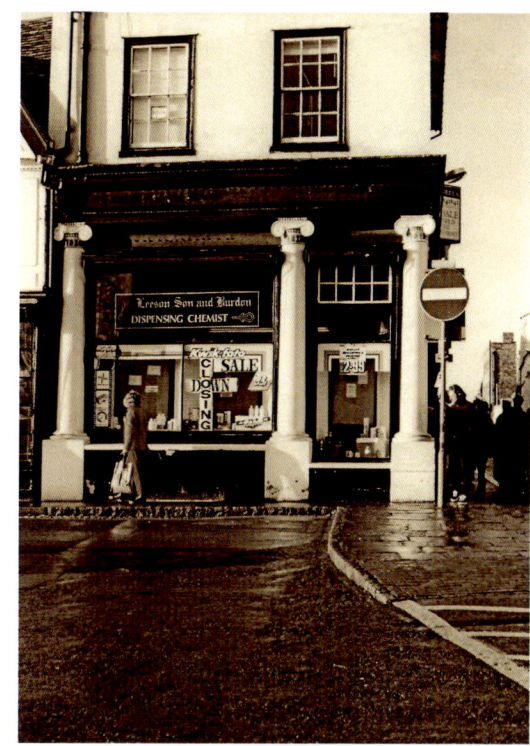

Right: Leeson & Burdon, Angel Hill.

Below: The pestle and mortar in Abbeygate Street.

VICTORIA LAUNDRY

This laundry in Victoria Street was founded by John Palfrey at the end of the nineteenth century. There were several hotels in the town at this time using the services of laundries to provide clean linen. The more affluent end of society also used them for starching and ironing shirts, bibs and collars. Those who could not afford their services would employ washerwomen instead. Horringer was known as 'The Wash Tub' of Bury as so many women who lived there brought home items of clothing to wash and iron.

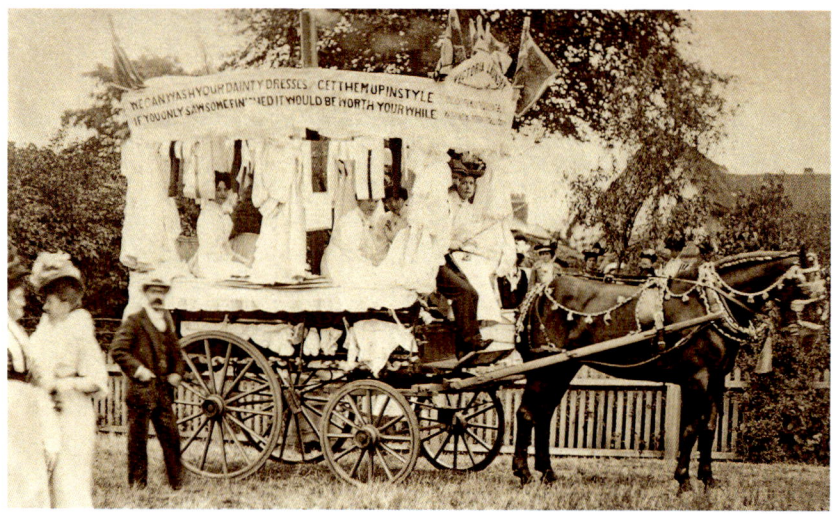

'We can wash your dainty dresses
get them up in style.
If you only saw some finished
It would be worth your while.'

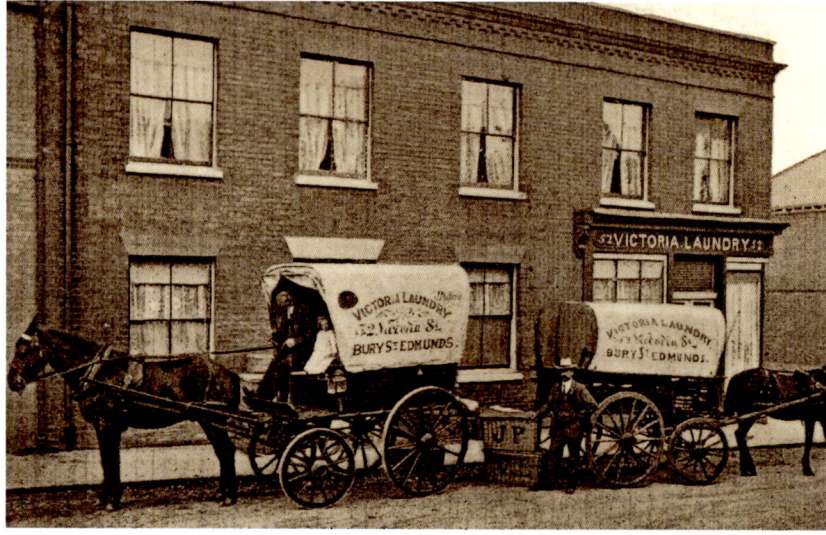

The Victoria laundry.

TWO CORN EXCHANGES

With the realisation that the corn exchange built in 1836 for dealing in grain was not big enough, it was decided to build a larger facility in 1861 – Lot Jackaman, once foreman to Thomas Farrow on the restoration of the Norman Tower, secured the contract. The old corn exchange became an internal provision market, but met with stiff opposition from market traders. It eventually closed and over the years has been a fire station, school of art, borough library, and public conveniences.

Above: The 1836 Corn Exchange, now the Halifax, Laura Ashley and Harriets Café Tea Rooms.

Right: The busy 1959 interior of the 1861 Corn Exchange.

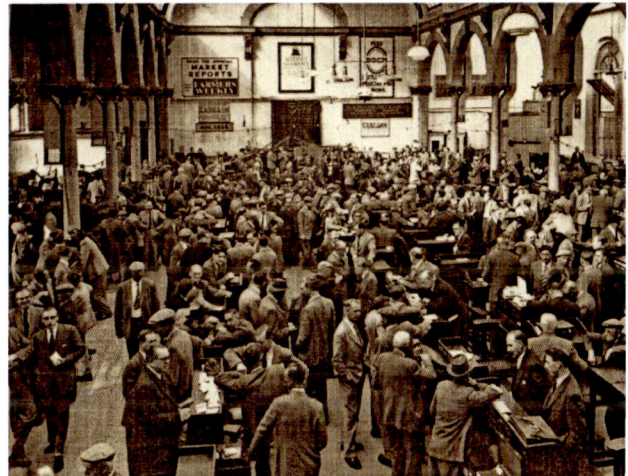

STEGGLES & SON BUILDERS

William Steggles and his son, also called William, were prolific builders during the nineteenth century, operating yards in the Brentgovel Street area and also owning a great deal of property in the town. William Snr, who died at the respectable age of seventy-nine in 1834, has his moniker at one end of Cannon Place, which was built in 1825. The Steggles family businesses were certainly diverse: one son named Humphrey was a malster; William Jr's son Edward was a chemist in Chequer Square; another son of William Jr's, William Henry, went into the family building firm, and his widow, Susan, was later a brick dealer listed at a house in Whiting Street (called Steggles Barn in recent years).

The Steggles builders favoured the Suffolk white brick, mainly from Woolpit, which they used on the Garland Street Baptist Church, the William Barnaby almshouses in College Street and the Guildhall. The latter was owned by the Guildhall Feoffees, as was Long Row in Southgate Street, which the Steggles built in 1811. Whether the family overstretched themselves financially is a matter of conjecture, suffice to say that in 1839 William Jr and William Henry were declared bankrupt in the London Gazette – the same year they were given the contract to carry out a major civic project. The project in question was Eastgate Bridge, which was completed in 1840. It would seem that their past trading record must have gone some way for the Eastern Counties Bank in Bury's Buttermarket (now Lloyds) to allow payment in one form or another to their creditors. You can see the family tombs in the Great Churchyard near St Mary's. William Jr died aged eighty-two in 1859.

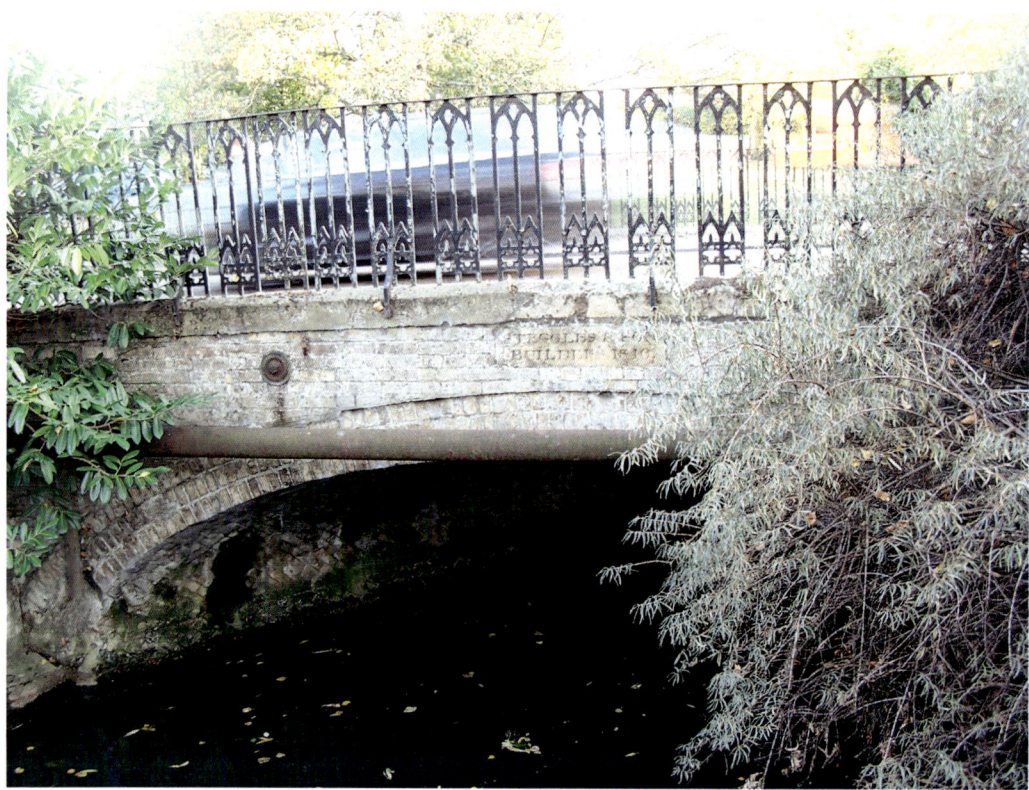

Eastgate Bridge today.

Nineteenth-Century Commerce and Service

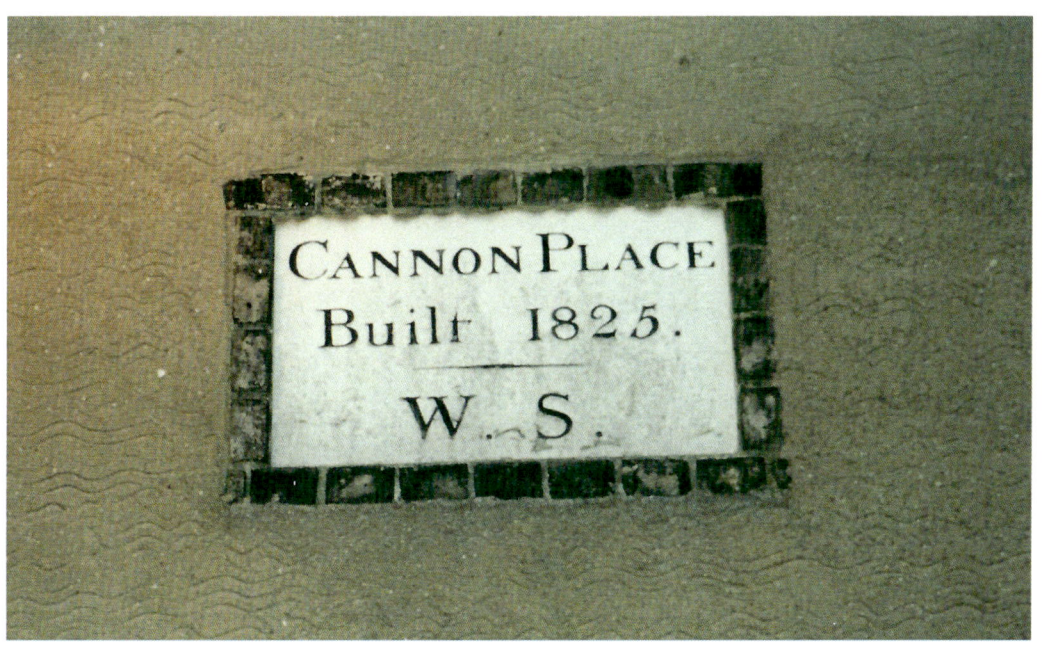

W. S. Cannon Place.

Steggles' tomb.

35

THOMAS FARROW, BUILDER

Thomas Farrow, a fine builder from Diss, had to put up a surety when he quoted to carry out the restoration of the twelfth-century Norman Tower. After centuries of use as a belfry for the adjacent St James', the tower was in danger of collapsing. Using specifications drawn up by the notable architect Suffolk-born Lewis Nockalls Cottingham, it was saved for posterity. Sadly, Cottingham died in 1847 before he saw the completion of the neighbouring three-phase pseudo-Jacobean Savings Bank House, which he had also designed. Farrow went onto build St Peter's Church in 1858.

Above: Savings Bank House from 1846.

Left: An entwined 'TF' for Thomas Farrow.

The Norman Tower.

St Peter's Church.

LEATHERWORK

There were still many traditional trades being carried out in the town, such as tanning, a process that relied on astringents such as oak tree bark and urine for the removal of hair from the skin or hide. The ancient craft of a cordwainer (the making of shoes from new leather) relied on tanning to enable this business to continue. A tannery in 1844, on the corner of Eastgate Street and Barn Lane, would eventually evolve into Ridley & Hooper Tanners, later coal and builder's merchants.

Ridley & Hooper's staff in the early 1970s, Out Northgate.

Bloomfields, Churchgate Street – alas, the mid-nineteenth-century bootmakers is no more.

THE TWENTIETH CENTURY DAWNS

The beginning of the century saw men from Suffolk involved in the South African War from 1899–1902, known today as the Boer War. There were 193 men from our county who died in this conflict. A memorial on Cornhill, auspiciously unveiled on 11 November 1904, has their names recorded for posterity. The town was moving at a pace. The internal combustion engine was gradually taking over and Pettitt's livery stable, on the corner of Kings Road with St Andrews Street South, was now advertising as motor engineers. The Angel Hotel was running a motorised taxi service to and from the railway station but the days of the Castle and White Lion, the two inns most utilised as carriers in the town, were numbered. Eastgate station, which opened in 1865 to cater for the line from Long Melford, had a short life, closing in 1909. With the expansion of the town now well underway, land to the north and west of it was being developed – fine Edwardian villas, for example, in Northgate Avenue and Albert Crescent. Builders such as Alfred Andrews, F. Warren and H. G. Frost were kept busy, while architect Archie Ainsworth Hunt designed houses for Barbrooke builders in Cemetery Road and Queens Road as well as drawing up plans for the building of the Shire Hall in 1907 and College Square in 1909.

Wellington Villas in Albert Crescent, 1901.

As we began this section with a war in South Africa we end it with another, the First World War, which took the lives of 427 people from Bury. The cenotaph on Angel Hill that was unveiled in 1921 has no names on; the names of those who made the ultimate sacrifice are recorded in a book of remembrance, turned daily in the cathedral.

First World War munition workers, aka 'munitionettes', at T. H. Nice & Co. of No. 21 Abbeygate Street, one of several businesses turned over to the war effort.

The Suffolk Regiment.

THE 1907 PAGEANT

During July 1907 a great pageant was held in the abbey gardens celebrating the history and heritage of our wonderful town. The renowned pageant master Napoleon Parker was appointed by the corporation to organise the event, watched over by a local committee of the great and the good and led by Mayor Owen Clark. The very accomplished local artist Rose Mead was chief costume designer and Lady Bunbury was controller of the working party. It seemed the whole town was employed in some form or function to provide this fantastic spectacle. A local printer called Pawseys produced postcards of the episodes that were drawn by Rose.

The barons and Magna Carta in Bury, 1214.

The expelled monks leave the abbey in 1539.

THE DECLINE OF INDEPENDENT BREWERIES

The Golden Lion Brewery in St Andrews Street South ceased brewing in 1896, but its tap lingered on at No. 57 Guildhall Street until 1907. The Saracens Head Brewery, also in Guildhall Street, went bankrupt in 1901. Clarke's/Risbygate Brewery was taken over by Greene King in 1917, along with twenty-eight owned and licensed premises. Though the timber-framed Clarke offices were taken on, the brewery at the rear was demolished, with Brahams scrapyard being here for much of the twentieth century.

Left: Golden Lion Brewery up for sale, St Andrews Street South.

Below: Alfred Bishop's Saracen's Head Breweries 1892.

Above: The Golden Lion Brewery before demolition.

Right: Clarke's Brewery offices, Risbygate Street.

THE FLAX FACTORY

In 1918, in and around what we know today as Cullum Road, meadows were purchased by the Board of Agriculture to grow flax so that the linen made from it could be used for the covering of aeroplane wings. Though the factory was in full production by 1919, the war's end meant a cessation of any further involvement in this linen-making process and the factory closed down in 1923/4. The workforce had consisted mainly of women, whose job was to break down the flax plant, remove seeds for future planting and then use a scutching machine to separate the long flax fibres, known as tow, and the woody waste matter called shive. The flax was then soaked in large retting tanks to soften the cellulose for around twenty days – the factory had its own spring, so the water supply was not a problem. It was then dried and the bundles of flax were combed through a 'heckling' machine to make the fibres straight, ready for spinning.

There was local opposition from Westgate Street residents when the factory opened, probably because their gardens overlooked the site. There was also opposition from Edward Lake, managing director of Greene King, which is surprising as his six sons uniquely all fought in the war. They all returned home too, a remarkable achievement that led him to donate a 26-acre recreational sports field (now known as the Victory Ground) not only in their memory but to twenty-one brewery workers who died in the First World War. After the closure of the flax factory, the largest retting tank was put to good use by locals for swimming.

New machinery for scotching.

The Twentieth Century Dawns

Deseeding the flax.

Flax bundles to be 'heckled'.

THE SUGAR BEET FACTORY

In 1925, the MP for Bury St Edmunds, Walter Guinness, the Minister of Agriculture, was involved in discussions to build a new sugar beet factory in Bury; two experts in their field, Dr Robert Jorisch and Martin Neumann, were brought over from Surany, Slovakia. A 45-acre site was chosen to the north-east of Bury and building commenced in 1925. Local landowner Colonel Long was very supportive of the factory as he knew that sugar beet was a good crop for the area. A new access road (Holderness Road) with housing for workers was opened; there was even a hostel built for Irish workers who came over to work in the 'campaign', The five-month harvesting season began in September when the beet was lifted. Until Compiegne Way relief road was built, many a local can remember the queues of overflowing beet lorries and tractors along Eastgate Street going to the factory and onto the weighbridge, then depositing their loads into large heaps. The beet underwent various operations: quality check, washing, getting sliced into strips called cosettes, then steamed to get the sucrose out, which was then dried, leaving sugar crystals. Nothing was wasted in the processing of the beet: washed-off topsoil was returned to farmers at a cost, stones were sold off, pulp was sold for animal feed, and the water returned to settle in huge lagoons.

Bury did not have a refining plant until the 1970s, when Silver Spoon's massive refining and packaging plant was built, its silos dominating the Bury skyline. The main players in establishing this sugar beet factory were to have subsequently very different lives: tragically Walter Guinness, 1st Baron Moyne, was assassinated in Cairo in 1944; Robert Jorisch married Norah Lofts, a celebrated local author; Martin (now Newman) was to have a grandson, the well-known TV personality Stephen Fry.

Building of the sugar beet factory, 1925.

The beet factory, known to my children as 'The Cloud Factory'.

British Sugar factory, 2017.

BUTTERMARKET

This major shopping area suffered from a Zeppelin bombing raid in 1915, with Days the Bootmakers and Johnsons Cleaners & Dyers being destroyed. As with any town, established businesses come and go, with examples such as the Playhouse cinema (which became the Quality House store, then Argos) and the Suffolk Hotel (which is now Waterstones and Edinburgh Woolen Mills). Shoe shops such as Bowhill, Elliot & White and Freeman, Hardy & Willis have also gone, while the traditional tobacconist Sextons finished after 100 years of trading. Debenhams, which took over the department store of E. W. Pretty & Co., finished after only twenty years, later re-emerging on the Arc development in 2009.

The market in Buttermarket.

The former Suffolk Hotel, which closed in 1996.

BURY MARKET

For hundreds of years Bury has had thriving markets spread out on the Cornhill and Buttermarket, consisting of different traders from all over that helped to create a place with lots of hustle and bustle. Some local stallholders who worked the Wednesday and Saturday markets kept their stands in the Kings Head public house, the Castle or White Lion yards. As time went by markets further afield became more accessible, with an assortment of goods now available to the shopper. The trader, on the other hand, is still very aware of increases in pitch rents.

Above: The marketplace c. 1920.

Right: John Webber – still on a market stall after fifty years.

END OF AN ERA

In 1908, the Greene King brewery started using motorised drays, with their last horse-drawn drays finishing in 1958. Booty & Son of Northgate Street and Childs bakery of Guildhall Street still delivered their milk and bread with a float, with their horses kept at the Butts. And who can forget that charismatic character Les Freeman, Bury's last rag-and-bone man.

An iconic picture of Les Freeman.

The delivery cart of Arthur Manning, baker of Out Westgate.

POST-SECOND WORLD WAR BURY

With the end of the war, temporary housing measures (prefab bungalows) were erected in various areas of Bury – all went well past by their sell-by date. The first real expansion out of the town's medieval boundary was to occur in 1946 with the start of the building of the Mildenhall Estate on 80 acres of land. The population of the town was around 20,000 and it was still heavily reliant on farming; this was all to change when the London overspill initiative was begun in the late 1950s. An assorted range of industries previously in the London area came here, attracted to the town with the promise of new purpose-built factories, offering not only jobs for Bury people but for their own skilled workforce. These people needed to be homed and so a new council estate, the Howard, was added to the Mildenhall Estate, followed by the Westley and Nowton estates. New industrial estates came as well, the first was Western Way, followed by Eastern Way, and lastly Northern Way. A new technical college opened in Out Risbygate in 1959, and plans were drawn up for a new hospital (now much extended) at Hardwick.

The West Suffolk Hospital.

While there has been much change to the peripheral outskirts of Bury, the town centre, constrained by its medieval core, had seen little transformation; however, this was all to change with the opening of the Bury By-Pass – no longer did traffic have to heave and strain, as the old A45 wound its way through the town. Undoubtedly the biggest threat to the uniqueness of Bury was the proposed demolition of St Johns Street, thwarted by concerned residents in 1970, who went on to become the Bury Society.

THE APPRENTICE SCHEME

Reputable Bury builder H. G. Frost was given the opportunity after the Second World War to set up an Apprentice Master scheme. The lads were instrumental in building two pairs of houses in Acacia Avenue in 1946 and 1948, along with a pair in 1947 in Avondale Walk on the Mildenhall Road Estate. Roy Atkins, now living in Warrington, was one of these apprentices. He lived then at Elveden, and one day in February 1946 his father came home and said to the fifteen-year-old Roy: 'I've got you a job to become an apprentice carpenter, you start straight away!' 'That was the best thing my father ever did for me,' Roy told me.

Apprentice plaque, Nos 9–11 Acacia Avenue.

Roy revisiting Nos 2–4 Avondale Walk in 2006.

THOMAS C. STEWART (CONTRACTORS) LTD AND ASDA

Stewarts was one of the first businesses on Western Way. They specialised in building and civil engineering, and after they closed Pordage & Co. Fruit and Vegetable Wholesalers were here until 1992. Asda submitted plans in October 2005 to build a modern supermarket on the adjacent derelict Co-op bakery/Leos supermarket site. It was not fully addressed until 30 March 2009, when Asda finally opened its doors after having built a superstore, car park and fuel garage on the large site.

Right: The boring but functional building of Thomas C. Stewart.

Below: Asda superstore.

BARBER GREENE

The beginnings of Barber Greene go way back to 1916 when two American engineers, Harry Barber and William Greene, got together to manufacture road-making and excavating machines that were able to carry out the work in a fraction of the time it would take labourers. The company was very successful, especially in the construction of Second World War airfields, and after the war they merged with the Hatfield firm of Jack Oldfield. He specialised in the refurbishment of tanks and track-laying vehicles left over from that conflict. The company, now known as Barber Greene Olding, moved to Western Way in 1962 after purchasing a large site for £0.5 million. The foundation stone to the new offices was laid a year earlier by the chairman, A. O. Bluth. Concentrating on road-making machines, especially those that laid asphalt, the company grew into one of the largest in Suffolk – at one time employing nearly 600 people. However, during the 1970/80s, problems in the Middle East meant a loss of exports, leading to a cut back in production, which resulted in redundancies. In 1985, Barber Greene moved to Great Saxham and a year later sold their Western Way site to St Edmundsbury Council for £1.5 million to raise capital. By downsizing and cutting its wages, it was hoped it would carry on, but this was not to be and the receivers were called in. Another company, BG Europa (UK), was set up, again utilising the expertise that existed in Barber Greene. The new company moved out to the premises in Wickhambrook, but were now a shadow of their former manufacturing self, dealing mainly in spares and acting as brokers for other asphalt- and bitumen-laying machines.

Barber Greene offices' foundation stone – opened 19 June 1962.

The last SA41 asphalt-laying track paver built by Barber Greene at Saxham in 1987.

Colin Green, export manager for BG England, with colleagues responsible for the SA41, the UK's most powerful paver.

VAN MELLE LTD

This Dutch company came to Bury around 1958/9, setting up home in Western Way. How many youngsters (not so young now) can remember the plastic bags full of small square-shaped yummy fruit-flavoured Fruitella chews that were brought home by employees? Suffice to say the confectionary business was doing exceedingly well, especially in the Middle and Far East, because in November 1983 the workforce was increased, bringing the number up to 200; after extensive training, the extra staff were used mainly on night shifts. Although always popular, their products suddenly hit a downturn and it was announced in February 1990 that 152 redundancies were to be made, causing a great deal of ill feeling. The factory was put up for sale in 1992, with Van Melle being bought out by an Italian confectionary giant and becoming Perfetti Van Melle in 2001.

VITALITY BULBS

Vitality Bulbs Ltd came to Bury in 1966 from Wood Green – their large modern factory was to be airy and full of light. The company manufactured lighting systems, especially miniature light bulbs, in their Anglian Way factory. In 1987, a management buy-out led to new names, the last being CML Innovative Technologies in 2004. This rebranded company, a leading manufacturer of LED signal lamps for all industrial applications, moved to Eastern Way industrial estate in 2010. Their empty factory was purchased by West Suffolk College (now part of UCS) and converted into a construction skills training centre. It was named in honour of Betty Milburn MBE, one-time chairman of the college governors; she had been keen to expand this training department. The Milburn Centre was opened during a special ceremony in May 2012.

The Vitality Bulbs factory.

Vitality Bulbs' shop floor.

Vitality Bulbs' spick and span canteen.

QUALITY CASTINGS (SLOUGH) LTD

Aluminium cast making by Ron Tarrant started from an old Nissen hut in Slough in the year 1957. His business grew successfully, and a nucleus of twelve members of staff were brought to Bury in 1968. This was the first company established on the Northern Way industrial estate, specialising in non-ferrous sand and gravity die castings. The factory, which has a very good health and safety record, has around 40–45 employees, many of which have worked here for a good number of years. Ron's son Peter is still at the helm.

Apart from the offices, there are three basic areas within the plant. The first is the gravity die section where molten aluminium is poured and five minutes later is solid enough to be cast out. Secondly there's the fettling shop, where each cast is cleaned off and checked over. (The term 'fine fettle' probably originated in the foundry industry). Finally there's the sand foundry, where a pattern of resin-bonded sand has the metal poured in at a temperature of 750 degrees Centigrade; because of the sand's absorbency the mould is left to cool down until the next day before the cast is removed. Customers include heavy automotive users such as Perkins, the petro-chemical industry and scaffolding companies. On a good day 1,000 couplers can be made.

There were once three foundries in the town; gone are Bobys Northgate foundry and Cornish & Lloyds – this is the last. Foundry work has changed very little over the years, the old adage 'if it ain't broke don't try and fix it' certainly applies here.

Resin-bonded sand moulds.

Gravity die pouring.

Fettling.

EASTERN WAY

In the 1950s, the borough set aside 40 acres for a trading estate, which was to become Eastern Way. Part of it, some 10 acres that adjoined the Cambridge–Ipswich railway line, was earmarked for Associated British Malsters (ABM). The building of their large office block started in 1960 with silos in 1961 and the malt dispatch block in 1964 (finished in 1966), and full production started later that year. Barley grain is measured in quarters, 4 quarters is equal to a hundredweight. At one time 12,600 quarters were being processed here weekly in preparation for breweries and distilleries. ABM was taken over by Pauls Malt Ltd in July 1987, which became a subsidiary of Boortmalt of Belgium, one of the largest producers of malt in the world.

There has been a number of companies operating from this estate since its inception: Bayer UK, a major player in the world of agro-chemicals, British Beef, and Lovell & Christmas, who imported New Zealand Butter – all now gone. Incidentally, parent company Fitch-Lovell had one of the earliest supermarkets in the country to use barcodes: Keymarkets, who were in Mildenhall Road, Bury, at one time. Several companies have been on Eastern Way for years: ABN (formerly Dalgetys), leading manufacturers of pig and poultry feeds, John Allan Aquariums (named after brothers John and Allan Riley of 1963), though now in different premises, and Eastern Counties Refrigeration, which started out behind Queens Road Post Office in 1972. Robinson Young were also founded this year by David Robinson and Sheila Elton, moving to Ibson House, Eastern Way, in 1982. In 2015, Robinson Young was announced as Non-Food Supplier of the Year at the Annual Landmark Conference awards night.

British Beef.

Right: ABM, Eastern Way, 1976.

Below: Boortmalt, Eastern Way, 2017.

VINTEN

Vinten, a London-based company, was founded in 1910 by William Charles Vinten. They manufactured camera equipment and eventually became a leading designer and maker of pedestals, tripods and supports for cameras – especially for television – to the highest engineering standards. Originally based in Cricklewood, north-west London, it was decided to move for the sake of expansion, and a site of just under 6 acres was purchased in Western Way towards the end of 1962. Bury was chosen as it seemed the friendliest when the directors visited the town and all the right boxes were ticked for staff, especially, to be able to commute back and forth to London when needed and still do a day's work. 'Bury St Edmunds, where's that?' was the most frequently asked question by the workers in London. They soon found out. They were given two years to find alternative jobs if they wanted to, then, apart from around fifty members of staff whose partners had good jobs or had children settled in school, the whole workforce moved to Bury in 1964. Bury Council were very sympathetic to the move of 132 members of Vintens staff, even providing 100 houses in the six-month resettling programme. By the end of the 1960s, the company was employing nearly 600 people. By way of encouraging the employees to fit in with the community, the Heron Social Club was built on site, successfully integrating with the other clubs and societies in the town until it closed in recent years. Always a family run business, the company went from strength to strength under the guidance of William's son Bill in reconnaissance and television. Sadly this kindly man passed away in 2015, aged ninety-five.

Employee Trevor Ansell precision engineering with a control-milling machine.

A TRANSFORMATION

Slowly but surely Bury was changing. The year 1973 saw the A14 opened; no longer was Looms Lane subjected to heavy traffic. Cullum Road and the Parkway also relieved the pressure on the town centre, though at a price: ancient pubs and Kings Road football ground lost out. The Northgate interchange and the wonderfully named Hellfire Corner at the top end of Out Westgate also meant the loss of several shops, while swathes of so-called low-quality housing were eradicated in several parts of the town, hygiene being as good a reason as any for their removal. What of the other shopping areas, we ask? If the council of 1970 had their way, we would have lost St Johns Street to concrete monoliths. The Corn Exchange would have gone as well; technically, though, we have lost it as it is no longer used for its original purpose, but instead has converted to a Wetherspoons public house. The west side of Cornhill also saw changes, who would ever have foreseen the closure of 'Woolies'? We saw the Sainsbury Cornhill supermarket close, only to open again on Moreton Hall, being replaced by the short-lived St Edmunds Fayre, only to reinvent itself again as an Iceland store. Undoubtably, the biggest change to Bury is the Arc development; I suppose it is a bit like Marmite. We were told there would be a link to it from Cornhill, which was supposed to be

The Focus/ Odeon – closed in 1983.

by the side of the post office, and we know what happened to that! What a pity the iconic Odeon was demolished for Cornhill Walk to be built. Could this go the same way, or will there be something new there in the foreseeable future?

THE BURY RAILWAY LINE

In 1948, the railway network in this country was nationalised, until it was privatised again during the years 1994–97. The Beeching Report published in March 1963 recommended a closure of over 2,300 stations and non-profit rail lines, such as the Long Melford–Bury line, which ceased to function in 1965. Bury station, which had opened in 1847, had several spurs off it at one time, there was also a great deal of employment, but gradually this waned – such as with the engine shed closure in 1959. A group of companies known as Railtrack looked after the entire British railway system with the advent of privatisation, but was put into administration and taken over in the same year – 2002 – by the state-run Network Rail, who is responsible for the rail infrastructure. In 2012, Abellio Greater Anglia secured the East Anglia railway franchise; they were successful again in 2016 for a nine-year period. Part of their package of improvements includes more services, faster journeys, the promise of thirty apprenticeships by 2019 and twenty trainees a year. This follows on from their investment of £1 million in the recent restoration of part of Bury station – including the station canopies. Hopefully this will continue, especially in the long-awaited renovation of the stationmaster's house. Smiths Row, the art gallery formerly in the Market Cross, are keen to take on this property. The importance of the Bury station cannot be emphasised enough. It is among the top sixty Victorian stations nationwide and has one of the busiest freight lines in Europe. Passengers using it deserve a first-class experience.

The line looking east.

A Transformation

Bury signal box that was listed as Grade II in 2013.

Bury platform, with restored valances on the canopies.

THE A14 BURY BY-PASS

This incredibly busy trunk road, which carries thousands of tons of container traffic from Felixstowe Port, was opened in December 1973. Part of it followed the old Sudbury–Bury railway line. The old Eastgate rail bridge was demolished and replaced with a road bridge. Another bridge carried traffic over Fornham Road, which then necessitated the removal of several properties.

Houses demolished for the A14 road bridge.

Earth movers!

THE TAYFEN

Always a wet area of the town, in the early 1980s an inner ring road from the Northgate interchange was proposed via Tayfen Road along Spring Lane, across the bottom of King Edward VI School playing fields until it met with Western Way. There were several businesses closed and properties blighted along the way, including Percy Fulcher Steelworks and the Greyhound track. For whatever reason the road was not proceeded with and Bloor Homes built a large development here called Tayfen Meadows.

Right: Tayfen Road – note the price of fuel in 2003!

Below: Tayfen Meadows under construction in 2001, one of 163 homes.

JEWSONS

John Watson was a builder, timber and slate merchant trading in Bridewell Lane in the late nineteenth century. His son's business, Charles Watson & Co., continued as a timber merchant until it outgrew the site. The Watsons then moved to meadows off Southgate Street (part of Almoner's Barn Farm in monastic days) and ventured into the world of builders' merchants until eventually taken over by William Brown & Co. of Ipswich in 1982. Their yard and showrooms were later acquired by building supplies giant, Jewsons. Their origins lie in the nineteenth century, when John Jewson moved to Colegate in Norwich and started a successful coal, timber and builders' merchants. One of his sons, Richard, went on to build one of the largest timber merchants between the Thames and Humber. The family were very much involved with civic duty, with members including a Lord Mayor of Norwich, and, more recently, a Lord Lieutenant of Norfolk. When Jewsons, who supply all elements of the building trade and now have around 600 branches nationwide, moved up to Cratfield Road, Moreton Hall, in 1989, a large housing estate called Sextons Meadows was built by Redrow Homes on the relinquished site. Several problems were encountered here due to the instability of the ground, which meant a lot of extra foundation work had to be carried out, as would be required years later at Tayfen Meadows.

Selecting timber in the Southgate Street yard.

A Transformation

Jewson's Southgate Street yard crew.

Jewson staff at Cratfield Road.

TREATT PLC

Treatt plc is a world-leading independent ingredients supplier to the flavour and fragrance industries, supplying products to food, beverage, cosmetic and pharmaceutical companies. Its founder, Richard Court Treatt, was born to affluent parents in 1854 in Exmouth, and after leaving school here he went to Italy, staying with family friends. He soon became multilingual and entered the diplomatic service travelling the world. In 1886, through one of his French contacts, Richard started trading in essential oils first in London then with suppliers from all over the world. His company went on to expand, bringing in new expertise; for instance, Mr Lauchlan Rose of Rose's Lime Juice fame became a director in 1943, retiring in 1973. Two years earlier, R. C. Treatt & Co. Ltd moved out of London, where it had been for eighty-five years. Bury St Edmunds was chosen out of a possible fifteen locations for its sixteen personnel. The Northern Way premises has since blossomed, with 180 staff, including forty chemists in laboratories, now occupying 5 acres with added storage and manufacturing facilities. In here, rare and exotic essential oils make up their unique range, which the company prides itself in producing for a clientele of all sizes. With a new brand name of Treatt Plc, it is one of just a few independent citrus-ingredient companies in the world, and certainly has the most extensive product range. Rather than sit on their laurels, the company now looks to the future under its current CEO Daemmon Reeve, with a move to a new purpose-built state-of-the art factory at the Suffolk Business Park, off Moreton Hall, and still proudly supporting the community, which plays a big part in Treatt's ethos.

Treatt plc distillation plant.

GLASSWELLS

Celebrating seventy years in 2016, Glasswells are the largest independent home department store in East Anglia. The year 1946 was when former grocer Gerry Glasswell opened a second-hand furniture store. In 1948, his son Leslie, freshly de-mobbed from the RAF, joined him and together they traded from a shop in Brentgovel Street, near to the corner with Risbygate Street. During the 1950s other shops were acquired: one around the corner in St Andrews Street South (now Palmers) and another in the Shambles to the rear of the Corn Exchange. By now the company had ventured into carrying out removals and doing big business, selling everything you needed to furnish your home. When the customer wanted their old table and chairs taken away, 'No problem there, sir' was the answer.

Leslie's son Paul joined the family firm and in 1989 became managing director, giving his father a well-earned break. Many of the staff – there are 280 plus – have years of dedicated service between them, a measure of the esteem this company is held in. At Christmas a reunion dinner for long-serving employees, past and present, is held at the Glasswell superstore in Newmarket Road, a time of year also appreciated by local pensioners who were given free tea and sugar as a small way of saying: 'Thank you for supporting us over the years'.

Inside the superstore.

DENNY BROTHERS

'Mighty oaks from little acorns grow' applies to this company because since starting in a humble garden shed in their parent's garden in 1945, Russell and Douglas Denny's printing firm has now expanded into a multimillion conglomerate. One of their first major printing contracts was for the fledgling West Suffolk Greyhound Stadium in Spring Lane for the Dutton family, using a second-hand printing press. From 1947 until 1960 their business flourished from their premises in Tayfen Road. Anything that could be printed on was from stationery to calendars. In 1965, Doug's son Barry joined the company. Further expansion led to the purchase of a site on the corner of Kings Road and St Andrews Street South; Denny Bros, using their new logo Db, are still here, a town centre presence so important for their stationery and art supplies. Without doubt the biggest influence on the future of the company was back in 1977, with the design and patenting of a simple but ingenious system of labelling products, Fix-a-Form. Pharmaceutical giant Bayer Agrochemicals had asked Dennys to come up with a way of informing the customer what was inside their packaging – dosages, for example – and so this multi-page label affixed to the outside of the product was born. In 1982, the firm acquired the old Bobys admin building, and two years later Barry became managing director. More expansion ensued, with them later moving into two units in Lamdin Road just off Mildenhall Road. Consolidation was to follow, and in 2001 they moved into Moreton Hall, an ultra-modern factory in Kempson Way. By now they were trading as an internationally recognised company, employing over 100 staff and winning various awards, such as Business of the Year in the Anglian Business Awards of 2012, and still going strong.

Denny Bros, on the corner of Kings Road.

A Transformation

IRONMONGERS

A Bury institution, Andrews & Plumptons was founded by Frederick Andrews back in 1862. They closed their doors at No. 90 Guildhall Street for the last time in 1988, though they survived in a reduced way in St Andrews Street South until 2000. With a second-to-none service, the shop was a treasure house of everything the DIY enthusiast or professional tradesman could want. Other Bury ironmongers to close were Henshalls at Nos 25–26 Cornhill, Underwoods in St Johns Street, and Nobles of Woolhall Street. Today, D. J. Evans in St Botolphs Lane still carries the flag for the independent ironmonger in Bury.

Above: Andrews & Plumptons, 1987.

Right: D. J. Evans, a depository of tools etc.

MARLOW & CO. LTD

In 1925, Edwin Underwood and Albert Marlow opened a timber company in College Street. Their yard occupied part of the old William Barnaby almshouses site and led to a showroom for bathrooms and sanitary ware in Churchgate Street. During the 1960s Edwin's son Ken and two grandsons, Philip and Michael, expanded the business and eventually new premises and yards were built in Hollow Road. Part of the very busy timber yard-manufactured roof gang trusses was eventually sold off to Howarth's Timber Engineering. The Marlows Home Interiors, Pet and Garden Centre still continues today and has a popular café.

Left: Marlows, College Street.

Below: Loading gang trusses.

A DIFFERENT BURY ST EDMUNDS

In 1828, the Beast Market moved, to much local opposition, from its Cornhill site to off Risbygate Street/Andrews Street South. The same sort of disapproval was aired when the announcement was made that the Cattle Market, an iconic part of Bury, was to close and be replaced by a modern shopping centre, the Arc. How bizarre that the name of the mad cow disease that contributed to the closure would have the same initials as our town, BSE! Bovine Spongiform Encephalopathy was endemic between 1986 and 1998, when 4.4 million animals were slaughtered nationally. In 1998, Bury's livestock market closed, along with many others, with demolition to follow – though Fabian Eagle continued with a deadstock market alongside the popular flea market for a short period. By 2002 developers Centros Miller were in deliberations with the Borough and the last vestige of the market, Pettit's tea hut, closed in 2006. Following an archaeological dig, the building work finally commenced in January 2007 by main contractors Taylor Woodrow. It was completed in March 2009 and cost close to £100 million. Many people could not understand why the Arc was called this and more so when the public entertainment venue was named the Apex after a costly consultation. Still, it has to be said that, although

Cattle market animal pens.

running severely over budget, the Apex is an award-winning venue designed by Hopkins Architects. Further discussion points are that of the design of the Debenhams store – not very Bury St Edmunds – the sacrificial stain given to the apartments above the high number of national chain shops, and whether there are sufficient parking spaces for this complex, which attracts high numbers of shoppers.

Above: The building of the Arc.

Left: The acoustically superb Apex auditorium.

PARKWAY

This central relief road from Westgate Corner to Tayfen Road opened in 1978. When part of the dual carriageway at the rear of St Peter's Church traversed a Victorian rubbish dump, pot lid and bottle collectors descended on this in droves. Further on, Cineworld, a multiplex cinema, opened in 2005 after several years of campaigning against it. It is now part of an American-style strip, with several food outlets and a multistorey car park that opened in July 1992. Parkway North now has the fire station, which opened in 1987.

Right: Looking down Parkway.

Below: Building of the multistorey car park in March 1991. (Courtesy of Norwest Holst)

THE CATHEDRAL MILLENNIUM TOWER

When it comes to modern-day-quality construction the Millennium Tower, so-named as it was started in 2000, is exemplary. Thanks to a substantial grant from the Heritage Lottery Fund and a generous bequest by the Dioscean architect Stephen Dykes-Bower, the tower was completed five years later, fulfilling the vision of his Gothic concept. Moreover, Bluestone (the chosen contractors) under the guidance of project manager Horry Parsons were not only able to complete within budget, but with superb workmanship. A lovely story told by Horry is associated with the mixing of the lime mortar to bind the 1,000 metric tonnes of Barnack limestone used; the story of Bill the labourer. He was entrusted to follow a formula of the exact quantities for the mix as laid down by 'boffins'. These came onto the site soon after work had commenced and watched Bill satisfactorily follow their instructions, even using his own dedicated mixer! At the last moment he whipped off his hard hat, dipped it into the water drum and added some water to the mix. Looking at their clipboards bemusedly, they quizzed him as to why he did that, he replied: 'Something is missing on that board you got ... experience'. And, do you know what? Every course laid was to perfection.

The final stage of the tower was the internal fan-vaulted ceiling, which Taylor-Made joinery of Bildeston did a fantastic job with. Millions of laser readings were used to measure the ceiling space, facilitating the superlative design with 2,500 components made from European oak. To finish off, London firm Hare & Humphrey (historic building painting contractors) used lead-based paint and 24-carat gilding. The finished ceiling contributed to the tower winning the RIBA Heritage East Spirit of Ingenuity Award in 2010.

The magnificent painted ceiling of the Millennium Tower.

WEST SUFFOLK HOUSE, WESTERN WAY

With the demolition here of St Edmundsbury House, the former Barber Greene offices, a major step forward was taken for the creation of a 'public service village', where St Edmundsbury Council and Suffolk County Council would share offices and their Highways Department would be based. Over 600 workers use this building on and off, with part rented out to other organisations. Designed by Pick Everard Architects, it has low energy demands, with two boreholes and a building structure that means constant temperatures, no air conditioning is present. The respective councils are now major employers in the town.

West Suffolk House – opened in April 2009.

The council depot off Olding Road.

WEST SUFFOLK HOSPITAL

This major employer of the town has grown massively in size from its opening in 1974. Spread out now in numerous extensions with various hospital departments, including the charity-funded St Nicholas Hospice. The level of care and treatment within this NHS hospital is phenomenal. With the site expanding over the years there has been a catch-22 situation parking problem: more employees, dedicated volunteers and visitors require more spaces, but at what cost?

Left: Second-year WSH pupils Sue Lloyd and Chris Harper with a nobody in 1985.

Below: A&E entrance.

DOUGLAS WARNE AND GRAFTON HARVEY LTD

These two clothing factories were in Bury at roughly the same time. Douglas Warne on Thingoe Hill made Girl Guide uniforms and sports clothing, while J. Harvey Ltd began in Hackney but have been in East Anglia since 1911. They opened up a men's clothing factory called Grafton Harvey in Tayfen Road, producing high-quality fashions for Burtons, Hepworths etc. They expanded to Grafton Manquest, with their cutters having premises on Station Hill. Unfortunately, nothing lasts forever, and the workers at Grafton Harvey were made redundant in the early 1970s.

Above: Douglas Warne's factory.

Right: Harvey's workers with redundancies.

HARDWICK INDUSTRIAL ESTATE

After the flax factory closed in 1923/4 a hand laundry was started here by Mrs Marjorie Nunn. Formerley Marjorie Kelsey, she had a laundry at No. 55 Guildhall Street, employing mainly village girls. The former factory was then acquired by an unmarried entrepreneur named Arthur Major. His relative George Forbes would marry Avis Killingley, the manager of Arthur's Chichester laundry. Together they went on to run the Bury St Edmunds Hand Laundry, with the Major family in a backseat capacity. Part of the site was commandeered during the Second World War when hutments and Nissen huts were erected to house soldiers guarding prisoners of war at Camp 260 on Hardwick Heath. After the war ninety-five people – mainly women – worked in the laundry.

The Hand Laundry eventually passed into the ownership of George's daughter, Sheila Forbes, and Jim Bayne, whom she met at university and eventually married. Further progress led to the opening of dry-cleaning shops under the name of Hardwick Cleaners, but as time went by the sale of more modern domestic washing machines and dryers meant the end of the laundry. In tandem with the laundry, various small businesses began using the former army buildings (mainly at the far end of the site). As starter units with flexible leases and affordable rents, they were ideal, though gradually more modern units were built. Businesses such as C. D. Friend & Sons (motor engineers) had their beginnings here, as did another car mechanic, Mike Moody. In digging his inspection pit he uncovered something very unwelcome: belts of machine gun bullets buried by the troops. Mike was one of the last traders on the site when it closed. Hardwick Gate housing estate, which was built on the Brownfield site, is still awaiting completion as the developer Landcharter went bust. Guildhall Properties, a former owner of the laundry site, went on to build Forbes Business Centre, off Kempson Way.

Former entrance to the estate.

MORETON HALL INDUSTRIAL ESTATE

After the borough had set aside 160 acres in 1973 for commercial and industrial use – in tandem with the large housing estate – there was a clambering for prime sites. Dencora Developments, formed in 1973, is now a privately owned commercial and investment company and were one of the major landlords on the estate, which has grown beyond all recognition, employing large numbers of people. The soon-to-be new Suffolk Business Park of 57 acres will have a road linking to the A14 near the Ravenwood interchange – a change to the commercial map of Bury forever.

Business information board on Moreton Hall.

Forbes Business Centre.

GREENE KING TODAY

Greene King, the country's leading pub company and brewer, employs more than 650 people directly. Among its five divisions are: the Pub Company, which has over 3,000 pubs, restaurants and hotels, with brands such as the Hungry Horse, Chef & Brewer and Old English Inns. There are also Loch Fynne fish restaurants and Pub Partners, who support around 1,200 licensees and Brewing & Brands. Greene King has two breweries: the Westgate Brewery in Bury and the Belhaven Brewery in Dunbar, Scotland. The latter was formed in 1719, which makes it the oldest brewery in Scotland. It was purchased by Greene King in August 2005 for £187 million. In 2000, the Morland Brewery of Abingdon-on-Thames was also taken over, but later closed down; however, their flagship ale, Old Speckled Hen, and their other trademark beers are now brewed in Bury. These are now part of the Greene King portfolio of well-loved beers, along with IPA and Abbot Ale, which are among the most popular.

In 1980, a new draught beer cellar was built on concrete 'stilts' in case the nearby River Linnet flooded. It cost £1.4 million and was designed by the renowned Hopkins Architects – the beer comes via a pipeline from the brewery. The raised cellar facilitates the easier loading of delivery lorries. Greene King's modernisation has rapidly increased since the Morland purchase. Across town, at Kempson Way, a new bottling plant was opened in 2006 (on the old Britvic site) costing £8 million. It produces 25,000 bottles an hour. Greene King is definitely looking forward and still supporting the community, such as with the opening of a Beer Café, plus the very popular brewery tour with knowledgeable guides. Not forgotten, though, are their retired employees, who can still enjoy a free pint on weekdays at the Brewery Tap.

The draught beer cellar.

Victor Ruddock adding hops to the sweetwort to make bitterwort, c. 1964.

Overlooking the brewhouse with older parts of the brewery on the right, including the modern triple-pipe stack.

A WEEKEND OFF WORK

There have always been favourite places in the town to gather, whether you were still at school or working. Under-age drinking was the accepted norm in certain pubs in days gone by, not so now. There were over sixty hostelries in Bury at the end of the 1950s. This decade onwards saw nightlife at the Co-op Hall and its dances, wrestling, roller skating and pop concerts at the Corn Exchange, with boxing and more dances at the Athenaeum – just some of the places you could spend your hard earned wages in Bury. During the daytime, cafés such as Drakes, Ron Smiths, Dunns, Jollys and Palmers were very popular, as was the Milk Bar, but perhaps the place most people can recall is Purdys. Their hot pasties with baked beans and oxtail soup poured were over-delicious to say the least. A friend of mine, Keith Hatton, frequented it and told me of his weekends back then. He was working as a labourer on the Vinefields building site at the time and earnt a very respectable £19 a week – far more than some of his contemporaries. With a couple of mates, Saturdays would be spent in Purdys followed by a stroll around town 'eyeing up the girls,' as he said, followed by one of the above venues at night. Sunday was spent having a lay-in and visiting the pictures in the afternoon – usually from 3 p.m. at the Odeon. Why did it seem that Hammer Horror films were always shown then? Afterwards, a slap-up three-course meal in the Griffin was called for, before arriving home around 9 p.m. and getting an early night for the day's graft ahead.

Keith Hatton on right and his mate Roy Todd, 1964. Purdy's and Winton Smith the butchers are in the background.

TOWN CENTRE BUSINESS

Towards the end of the last century, an organisation funded by the Borough Council and voluntary contributions from businesses was set up to hear the views of other businesses. Town centre managers were even appointed by the council. Their remit was to increase visitor numbers and oversee specific events, but they were hampered by how resources were structured. The council pulled the plug on core funding during the middle of the millennium's first decade and the businesses had to go it alone. A Business Improvement District (BID) was suggested and a ballot in late 2009 from this saw Bid4Bury born. The new organisation would be funded by a levy of 1.75 per cent on any rateable value of £10,000 or more that any business within the defined area of reference was paying. This contribution meant that a pot of £300,000 per year was now available in creating a marketing strategy. A charismatic former police superintendent named Mark Cordell was appointed the second CEO in February 2011 and he soon set about getting more members. There are currently 466, twenty-three of which are outside the area of benefit but can see the value of being involved. In 2013, there was a name change, it became Our Bury St Edmunds BID. Then in 2014 those members within the town centre voted positively for a second term of five years;

Mark Cordell with Mayor Julia Wakelam giving an award to No. 6 Abbeygate Street for best-dressed Christmas window of 2016.

a renewal ballot is planned in late 2019. The BID has raised the profile of commerce in the town, with the visitors' footfall increasing every year since 2012, bucking national trends. The many supported events – such as floral displays, Christmas lights, Whitsun Fayre and the Food & Drink Festival – make Bury a very desirable, attractive and safe place for people to enjoy the many retail, food and drink offerings here.

ST JOHNS STREET

Until 1842 this street was known as Long Brackland, but the building of St John's Church brought about a name change. The major buildings here are this church, the former police station of 1891 and the Quaker Meeting House. The charm of the street is the eclectic mix of independent shops (thanks to the concerned Bury residents of 1970), because their diversity adds so much to the town's uniqueness. Copelands Interiors are still going strong in their original premises from 1884.

'Independents Day', 4 July 2014. Bay Tree Bistro owner Nicola Redmond receiving a Best Independent award from Mark Cordell.

Rogers in 1989, a once-popular toyshop – alas, now gone.

HOTELS AND RESTAURANTS

Tourism plays a huge part in the economy of Bury. A hotel from the national chain Premier Inn opened up in the former Shire Hall in 2015 and is doing very well. The Angel is looked upon as the premier hotel in the town. Charles Dickens visited the Angel on more than one occasion and has his eponymous hero Samuel Pickwick staying here – his servant Sam Weller 'performed his ablutions' at the pump in the yard. Though we still have several other good hotels in the town centre – such as the Chantry and the Abbey and very recently a 'boutique hotel' called the Northgate – we have lost several over the years. Two of the town's favourite watering holes for locals, the Suffolk Hotel and Everards Hotel, are gone forever, having been turned over to shops. With any hostelry, service, cleanliness and comfort is ultra-important, as is quality of food and presentation. In these days of Trip Advisor a bad review, even spurious, requires a swift reply. Sometimes price to some people is not the overriding factor; ambience can be a major motive for repeat visits. Bury is well served by a wealth of pubs, cafés, bistros, coffee shops, fast-food outlets and top-notch restaurants all vying for a 'piece of the action'. You can certainly say the resident or visitor to Bury is spoilt for choice – variety the spice of life!

The Angel Hotel.

WOOLWORTHS

Charles Best's draper's premises on Cornhill became a bazaar in 1929 for American company F. W. Woolworth & Co., which then sold anything and everything very cheaply – similar to the £1 shops today. They moved into a larger store in 1952, on the site of Henshalls ironmongers. Nationally, the company had a store in every major town and city and was a big employer – those working on the pick 'n' mix evidently had the best job! A decline in Woolies' fortunes led to their closure; the Bury store closed in December 2008.

Woolworths staff, c. 1960.

PALMERS, DEPARTMENT STORE

Palmers, a family run business from Great Yarmouth, purchased Plumptons (on the corner of Buttermarket and Abbeygate Street) from a Mr Pemberton in 1961. Plumptons became Palmers around 1974. William Plumpton had started his linens and drapery business over 100 years earlier, but Palmers had been started in 1837 by Garwood Barton Palmer. He was joined in 1844 by his son Nathaniel, and eventually his two sons took over. The current chairman, Bruce Sturrock, is the great-great-great-nephew of Garwood. After the Dereham branch was sold off recently, there are now four Palmers shops left – at Great Yarmouth, Lowestoft and two in Bury. Palmers, Bury's only independent department store, sells up-to-date fashions, lingerie, fragrances, shoes, luggage etc., while Palmers Homestore in St Andrews Street South sells a whole range of goods for the comfort of your home. Well, it does at the moment; a planning application to convert the property into residential and smaller retail usage has been applied for.

JAVELIN, ABBEYGATE STREET

In 1864, John Adam Scotcher had a gunsmith shop at No. 17 Meatmarket (The Traverse) until the beginning of the twentieth century when his business was acquired by Henry Hodgson. He traded from here until his death in 1916, then his widow carried on running the business with the help of Harry Bennett, who went on to marry her daughter. The shop continued under the Hodgson name and was in the Bennett's possession until his death in 1953. Robert and Violet Clayton then became the owners until they retired in 1976, their son (also called Robert) continued the family connection, being joined in this respect by his son Jeremy. They became a partnership and known as Clayton Sports. When the prime corner site of Abbeygate Street and Angel Lane (previously Cramphorns and also Westgates Seeds) became available, they decided to relocate. The move went ahead and they started to sell guns for field sports, but had a greater emphasis on ski-wear and equipment. They later decided to stop selling the guns. Gradually the shop has built up a boutique reputation, selling top-quality designer men's and women's wear. Further growth saw expansion into the adjacent shop at No. 38, once Payne's China shop and Carousel Fashions. In 2012, Javelin won a Drapers Award for 'Independent Womenswear Retailer of the Year' and in 2015 were a finalist in Menswear – equivalent to an Oscar in UK fashion.

Jeremy Clayton.

MARKS & SPENCER PLC

A ladies' and gents' outfitters, W. Gates & Son in Buttermarket was demolished to make way for this branch of Marks & Spencer Ltd, which opened in October 1932. The original central façade still has 'Marks & Spencer Ltd' on – one of only a handful in the country to do so. Wings were later added either side while, to the rear in High Baxter Street, more extensions created further facilities. Jackie Cook née Chadwick can remember starting at the Bury store in 1967, a very prestigious place to work as advised by her teachers at the Silver Jubilee Girls' School. As a shorthand typist to the then manager of the store, Mr Cumber, this also involved working on the sales floor, which she much preferred. She progressed to become a window dresser, a supervisor and then, for a time, in the Personnel Deptartment. There were plenty of opportunities to train in other departments or at other stores. When she started, there was just a ground sales floor with a small department for food; on the first floor there was a large stockroom, offices, training room, a large restaurant etc. It was here that many social events were celebrated, so it was fitting that Jenny Bradley née Steed commemorated her fifty years of employment with a visit by the then chairman of the company, Sir Stuart Rose. Jenny was one of five Steed sisters who worked here – they have 140 years of service between them. Marks & Spencer plc are well known for looking after their staff. Staff could even have their hair cut during their lunch hour, with food brought to them on a tray – now that's what I call service!

The Buttermarket store, 1959.

The Diamond Jubilee reunion of 1992.

Staff celebrating in 1992.

NOW GONE

In *White's Directory of Bury* in 1874, sixteen retail greengrocers and fruiterers were listed, but now there are none. The last greengrocer's stood on the corner of St Andrews Street South and Risbygate Street, and was owned by Richard Green until it closed in 1998. The closure of the general post office in 2016 was also a great blow to the town centre. The post office is now located in the adjacent WHSmith shop. The year 2016 also saw the final shops within Cornhill Walk close – the future awaits.

Left: Richard Green's shop in May 1998.

Below: The post office.

THE TRAVERSE

The Traverse is part of Bury that has a varied collection of businesses, from the smallest pub in England – the Nutshell – at one end, to Croasdales the family chemist at the other. Midway is Cupola House, an apothecary from 1693 that was owned by the Macro family. As Strada Restaurant, this iconic building of Bury was consumed by fire in 2012 and it was only the professionalism of the emergency services that prevented a rerun of the great fire of 1608 that destroyed most of the town centre.

Post-fire at the Cupola. This was rebuilt by 2016.

Looking down the Traverse.

WHAT OF THE FUTURE?

It has not been possible within these pages to give a concise portrayal of all the occupations that have been, or will be, in Bury. I have merely offered a glimpse of the past and present, but what of the future? With the expansion in recent years of West Suffolk College, now part of University Campus Suffolk, further education now offers so much to all those willing and able to use the facilities. Better job prospects are more realistic than ever. We know that the town centre is constrained by its medieval grid, but the predicted level of employment growth will probably not be here but within areas such as the burgeoning Suffolk Business Park. It is hoped Bury will not become a satellite of the more expensive Cambridge, though some of the occupants of the 5,000-plus houses (part of Vision 31) being built in and around Bury will obviously work there. Another important issue to keep in mind is there should be a balance of affordable accommodation for all. There is also a great deal of pressure being put on the infrastructure of the town, such as the traffic flow and parking; the town centre masterplan – still in its infancy – will hopefully look to come up with a solution.

To encapsulate: will Bury St Edmunds lose its identity? Will we become another clone town? I am sure we will hang on in there because the thousands upon thousands of visitors who come here week after week, year after year, appreciate its uniqueness. Tourism adds so much to the economy of the town. Some tourists become residents who are proud to live and work here – there are opportunities for all!

West Suffolk College, Out Risbygate.